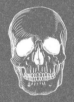
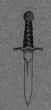

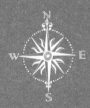

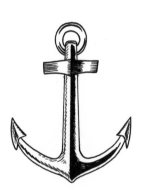

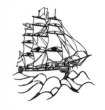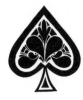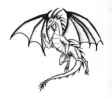

THE

TATTOO

DICTIONARY

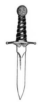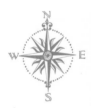

An A–Z guide
to choosing your tattoo

TRENT AITKEN-SMITH

ILLUSTRATED BY ASHLEY TYSON

MITCHELL BEAZLEY

For Kayley, Eden, Sidney & Hunter.

Contents

Introduction

I cannot remember a time that I have not been fascinated by the art of tattooing. Tattoos are a symbol of freedom and self-expression, as well as one of the few things in life that we can truly own without the risk of having it taken away. They are markers of a life journey, of thoughts and ideas, as well as snapshots of exact moments in time. I have many tattoos and each has its own story – even if that story is as simple as having some spare time and a willing artist to hand.

I got my first tattoo when I was a teenager. Lost in that crazy tidal wave of first love, I had my girlfriend's initials tattooed on my arm in less than pleasant surroundings and with somewhat primitive equipment, to say the least. But I was marked. My journey had begun. It was about a year later that I got my next one, a cover-up of the now-ex-girlfriend's initials. Some years after that, this second tattoo was also covered up as it was on a premium location (my upper arm) and was small and badly placed.

As you can probably tell, my first forays into the world of tattoos were not led by intelligence or forethought; emotion seemed to be the driving force. Thankfully, over time I started thinking about tattoos a little more carefully.

I have spent many years immersed in the world of tattooing and during that time have heard just about every possible reason for getting a tattoo – from the completely surreal to the perfectly logical. What I love most about these tales is their sheer diversity – I have always found that the reasons behind a person getting a tattoo are as fascinating as the designs themselves.

With this in mind, even my own early tattoo choices now hold personal meaning and significance. It is only by understanding the memories and message behind the tattoos that they reach their full potential. The tattoos tell a story. They contain symbolism and meaning beyond their simple visual exterior, whether they were intended to do so or not. They are external displays of internal beliefs.

And it is on this symbolism that this book focuses. It is a guidebook to common designs, symbols, and motifs in the tattoo world – a way to decode the meanings behind the ink.

The world of tattoo design and the symbolism used within it are incredibly complex, dating back thousands of years and encompassing a huge number of groups, cultures, and even civilizations. This dictionary could not possibly cover all of this in depth, and does not aim to. Instead, it selects some of the most common and popular symbols from both the world of modern tattooing and the modern world itself, and outlines the often captivating stories behind them.

All of the entries in this book were chosen because they were either intrinsically linked to the tattoo world – traditional sailor tattoos, for example, or the tattoos worn by the Japanese criminal gangs known as the yakuza – or because their meanings are so engrained in our psyche that they have become part of the

tattoo vocabulary and are now popular motifs – ancient symbols like the Buddhist Om, for example. Also included are broader entries that cover various common tattoo styles and design terms, many of which are heavy with a symbolic meaning of their own.

The Tattoo Dictionary is intended as a source of inspiration as well as offering some guidance and illumination. Whether you have decided to get a tattoo on the spur of the moment, or have been planning one for years, down to the smallest detail, knowing something about what you are going to get tattooed with does help – particularly when dealing with symbols or iconography that are steeped in historical or cultural significance. Tattoo circles are rife with stories of people choosing to have a kanji tattoo, for example, only to discover that, through some basic mistakes, they are permanently marked with something that reads "One Dog" instead of "One Love".

Ultimately, the aim of this book is to open up something of the fascinating history of tattooing and its uses in countless cultures over the years. Whether you are looking for inspiration for a tattoo of your own, or simply interested in the rich and varied stories embedded within this unique art form, I hope that this text is of some help in allowing you to understand the hidden meanings embedded within many tattoos, and – perhaps – to create your own life story in ink.

—*Trent Aitken-Smith*

 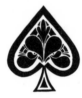 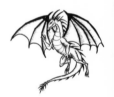

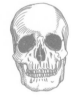 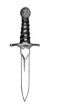

SEE ALSO
"Mi vida loca" *p147*

"A.C.A.B."

Though this tattoo is not widely seen anymore, historically A.C.A.B. (All Coppers Are Bastards) was a popular tattoo in the British criminal underworld. A.C.A.B. is an old English gang and prison tattoo that was first reported on in the 1970s, although its first usage was thought to originate earlier, in the 1920s. The use of this acronym as a symbol of the anti-Establishment was popularized in the 1980s by the British punk band 4-Skins, who released the song "All Cops Are Bastards". As the tattoo became better known to the general public, or more importantly to the police, often the acronym was replaced with the numbers 1312, or by a single dot on each finger. In later years, the acronym was picked up by Ultra football supporters throughout Europe, who often had run-ins with the police. In Germany, having A.C.A.B., or even the numbers 1312, tattooed on your body are deemed an insult by the courts. In all instances, the tattoo usually appears on the knuckles, though it can be placed anywhere on the body.

SEE ALSO
Man's Ruin *p136*
Playing cards *p171*

Ace of spades

The ace of spades has always been one of the more significant cards in a deck of playing cards. Not

only is it traditionally the highest card, within the highest suit, but it was also the card that was used to show the name of the company that had printed the pack of cards and whether stamp duty had been paid on the cards or not. Because of its strength within the pack, the ace of spades was often viewed as a symbol of good fortune. During the Second World War, soldiers (particularly within the airborne division) would paint the ace of spades on their helmets. Years later, during the Vietnam War (1955–75), the ace of spades was used as a psychological weapon against the Vietnamese, because, within Vietnamese culture, the card represented death and ill fortune. The ace of spades is still a popular tattoo choice, especially within the old-school style of tattooing.

Adinkra

Many symbols we see today are the result of people attempting to convey meaning before the existence of writing. One of these sets of symbols was used by the Akan people, whose traditional homelands lie on the Gulf of Guinea in the present-day West African republics of Ghana and the Ivory Coast. These pictograms are known as *adinkra* symbols and are traditionally said to date back to 1818, although they may certainly be somewhat earlier: a piece of cloth carrying 15 *adinkra* symbols including stars, drums, and diamonds printed in vegetable dye goes back to before this period. In 1927 an explorer visiting Ghana recorded some 50 different symbols in use by the Akan people, representing different concepts, or sayings, related to the world around them and their culture. At the time of their discovery, *adinkra* symbols could be found everywhere in Akan culture – on cloth, jewellery, and other handmade objects, as well as on the

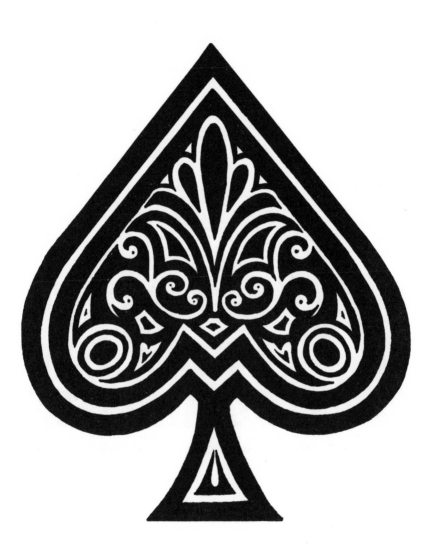

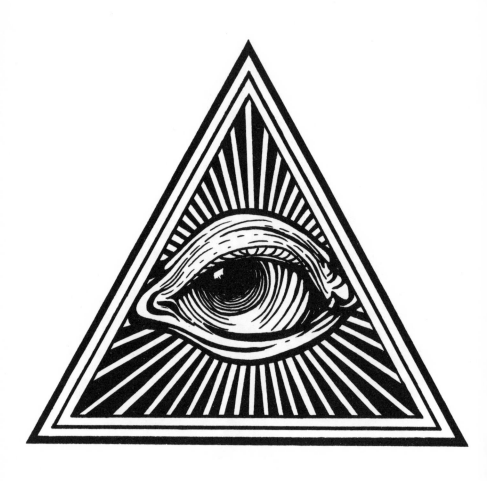

walls of buildings and houses. *Adinkra* cloth is especially highly prized, donned by Akan royalty and spiritual leaders on special or ceremonial occasions such as funerals, although today commercially made cloth is worn much more widely. Unfortunately, because most of Akan history was passed down orally, some of the names of these pictograms have been lost and, along with them, their original meanings. Therefore, some are known today only by their visual representation, such as the symbol for the cowry shell. Others, however, have survived with their full meaning intact, which can often be quite complex.

All-seeing eye

The all-seeing eye is one of those motifs that has its origins in ancient history but which, through time, has been appropriated by various groups so that now its associations evoke mixed reactions. Within many ancient cultures, the all-seeing eye was a direct reference to the gods and their omnipresence, as well as a symbol of divine providence, and can be found quite frequently in art. In later art and illustration, the all-seeing eye is often shown as a single eye, surrounded by rays of light and encased in a triangle, though this is far from its original design, which was usually a more stylized rendition of an eye, such as found in the Egyptian Eye of Horus. Probably the most recognizable place the motif can be found these days is on the US one-dollar bill. Freemasonry has also adopted the all-seeing eye into its lexicon of symbolism, where it serves as a reminder to all Masons that their thoughts and actions are always being observed by God. Often, as in the one-dollar bill, a pyramid is incorporated into the design.

Anchor

The anchor is a symbol that seems to appeal to us no matter whether we have spent our life on shore or at sea. It is a simple, yet strong, image that is both instantly recognizable and, on the face of it, easy to interpret. A symbol of strength, stability, and steadfastness, it is not hard to see why it is such a popular image. However, because of its very simplicity, its central statement can be easily adapted to fit a wide range of beliefs and is, therefore, open to a wide range of interpretations. The most obvious example of its use as a tattoo is by navy sailors and members of the merchant marines as a sign of their profession, with the added symbolism of strength, steadfastness, and good fortune. The anchor was a very popular tattoo in the early days of tattooing and can be found on many a sailor or flash sheet. On the other hand, the anchor can be used as a religious symbol, a sign of the wearer's strength in their chosen faith, or simply as a reminder to always remain grounded, no matter how stormy life may become.

Angel

Ever since humans first developed a sense of their individual place within the greater order of life and death, angels have played a central role in culture and, therefore, art. Angels represent everything that we cannot attain as mortal beings. Though their form and representation may differ greatly, angels can be found in nearly every religion, their role nearly always as messengers between humankind and the gods, or as beings who act as our protectors or guardians. Though we now commonly depict angels as beautiful winged creatures who shimmer with

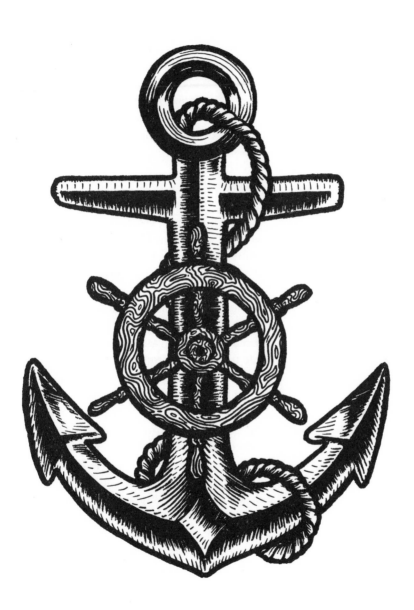

innocence and purity, this is a largely Christian viewpoint – a Western understanding of angels. In other religions there are beings that, though they might not, on the surface, appear to be angels, perform a similar function, that is as messengers of the gods. Examples include the Valkyries of Norse mythology who brought fallen warriors to Valhalla and the devas of Buddhism, invisible spirits who inhabit the airy realms between heaven and earth.

SEE ALSO
Cherry blossom *p48*
Manga *p135*

Anime

Anime is a Japanese cinematic art form that is entirely created using hand-drawn or computer-generated animation. Though the term "anime" is used in Japan to cover all forms of film animation from around the world, covering Western as well as Eastern films, in the West anime refers specifically to movies animated in Japan. Anime specifically made in Japan has been around for a long time, the first professional short appearing publicly in 1917. Since then, its popularity has grown over the years, reaching its zenith in the 1970s. The apparent spike in anime films during this time has been put down to the surge in popularity of another Japanese graphic art, manga (Japanese comics). Though manga already had a small cult following outside of Japan, during the late 1970s and early 1980s it hit mainstream media in parts of the Western world, and studios began to turn these comics into animated movies. Besides being made in Japan, anime is recognizable by its design elements, especially the exaggerated physical features of the characters – notably the eyes – and the stylized rendering of scenes, both of which make its translation into the art of tattooing both simple and effective.

SEE ALSO
Arrow *p21*
Love dots *p130*

Apple

The humble apple has long found itself a niche in
art, mainly thanks to Christianity and the story
of Adam and Eve. Through Adam's infamous act
of taking a bite from the forbidden fruit, which
resulted in his eyes being opened to the secrets
of the world and ultimately in both his and Eve's
loss of innocence, in early art the apple became a
symbol for hidden knowledge. The Golden Apple
is an element that features in various fairy tales,
which often follow the same theme – a hero who
has to retrieve an apple that is usually guarded
by a ferocious antagonist. In later art, the apple
has been used to represent love, though usually
the passionate, physical side of love rather than
its spiritual aspect. This association has been
theorized as being influenced by the biblical
story of Adam and Eve, though it is thought that
the apple's rounded, full-bodied appearance as
well as its sweet, juicy flesh have had something
to play in this, too. In some mythologies, such as
the Norse, the apple is considered sacred, divine
food and as such a source of immortality, and a
symbol of rebirth and beauty.

SEE ALSO
Kewpie doll *p120*

Arrow

Within hunter-gatherer cultures, the arrow has
always held strong symbolic meaning, not only as
a tool that is used to sustain and protect, but also
in more philosophical ways. One of the strongest
and longest-lasting associations is found among
the Native Americans. For these peoples, the
arrow was a hugely important symbol that quite
literally meant life – it was the tool they used to
hunt for food to feed their families as well as the
weapon they used to protect them. It was a symbol
of war as well as peace. Within Native American

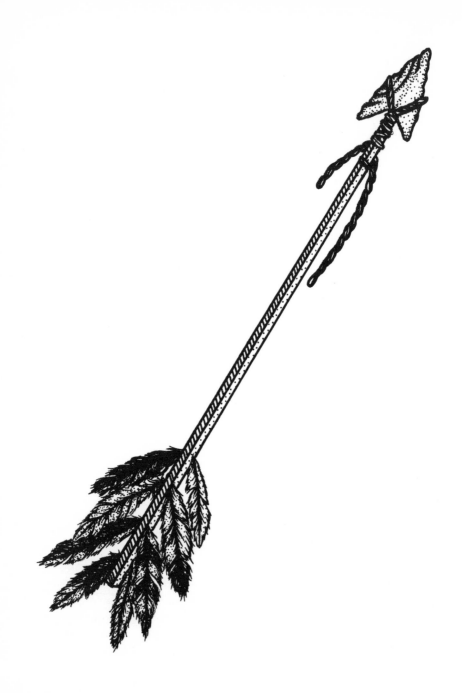

cultures, the sign of two crossed arrows is used to represent an alliance, while an arrow broken in two is a sign of peace. Of course, arrows are also commonly associated with Cupid, the Roman god of love, so it is often used as a symbol of passion, affection, or love. But probably the true power of the arrow lies in the ease with which it can be adapted to convey an individual meaning, based on its use and appearance. An aesthetically simple, yet striking, image, the arrow remains a powerful symbol however it is viewed or interpreted.

Aryan Brotherhood

The Aryan Brotherhood is a predominantly prison-based gang that was started in the mid-1960s. Infamous for its outspoken white-supremacist leanings and violent deeds, the Aryan Brotherhood initially began life in San Quentin State Prison, California, but soon spread to other prisons across the United States. Members of the Aryan Brotherhood have a wide range of tattoos that show affiliation to the gang, but among the best known are the shamrock (considered to be a reference to the two American-Irish bikers who started the Brotherhood); the Brand (another name that the gang goes by); the letters AB or numerals 1 2 (the latter representing the placement of the initials AB in the alphabet); and 1488. The numbers 1488 are used not only by the Aryan Brotherhood but also by neo-Nazi groups, and refer to the 14-word ideological statement, "We must secure the existence of our people and a future for white children", and to the eighth letter of the alphabet (H), doubled to stand for "Heil Hitler". These symbols can generally be found anywhere on a gang member's body.

Avant-garde

Also known as "abstract", avant-garde, in tattooing terms, is a style that came out of Europe, which is where its leading artists predominantly work from. At first glance, avant-garde tattoos seem to have no meaning or formulated design; most seem to be awash with free-flow splashes of colour, misplaced lines, and objects that do not seem to fit with one another or with the rest of the tattoo. In addition, with avant-garde there is often a mixture of styles – script, neo-traditional, and blackwork. The overall feel you get from avant-garde is that the artist has been let loose with no clear idea of an end goal or how to get there. However, this is not the case. Avant-garde tattoos are often loaded with symbolism and meaning – the artist has just chosen a more abstract method to convey these to the viewer. There is a feeling of freedom and serious playfulness in avant-garde. The only drawback to this term is that it can sometimes be a catch-all for styles that do not fit into any other style category.

Barcode

We live in an age of computerization and one of
the mainstays of this technology is the barcode,
developed by the US engineer Norman Joseph
Woodland (1921–2012) in the 1950s. The barcode
originally took the form of concentric circles,
but when IBM decided to push the barcode as a
Universal Product Code (UPC) it was redesigned
as the set of vertical lines that we so commonly
see today. The barcode has become a common
design within tattooing as an iconic symbol of
modern life and our immersion in technology;
it is a visual representation of how most of what
we do, or use, is governed by mathematics and
computers. If done properly, barcode tattoos
can hold information that can be scanned and
read, though, as per standard barcodes, what
can be held within the barcode is very limited. In
addition, the artist doing the tattoo would need
to be highly skilled, as the lines, and the gaps
in between the lines, have to follow a standard
width and length and there can be no bleeding
(i.e., the lines have to be solid and straight-edged)
if the barcode tattoo is to be read by a scanner.

Bast

Ancient Egyptian iconography has always been
popular within tattooing as it often features

animals and generally ornate motifs. One of the most popular of the Egyptian deities is Bast (or Bastet), the cat-goddess. Within Egyptian mythology, Bast personified the attributes we would generally associate with cats – playfulness, cunning, and grace – as well as the fierce power of their larger wild relation, the lion. The name Bast can roughly be translated as "Devouring Lady", and she was often depicted in the simple form of a cat or as a woman with the head of a cat, though originally she had the head of a lion. Cats were greatly valued in ancient Egypt as they protected crops and harvests by killing vermin, and therefore Bast was often seen as a protective goddess. Because of their divine associations, cats were often looked after by temple priests, which in turn led to them being seen as lucky.

SEE ALSO
Rat *p177*
Wings *p238*

Bat

Probably because of their nocturnality, bats are one of the most misrepresented creatures in the animal kingdom. We associate them with dark nights and the occult, and they were traditionally considered to be the familiars of witches, demons, and vampires. Seemingly not quite birds and not quite mammals, with their wings of skin and strange faces, they seem to belong to another world, outside of what might be considered "natural". Popular culture has long associated them with the dark or evil side of life – sinister creatures that haunt our nightmares. In some cultures, bats are seen as the winged souls of the dead, the Madagascans viewing them specifically as the souls of criminals. There are some positive associations with bats, however: in China they are symbols of good fortune, while Native Americans associate them with rebirth.

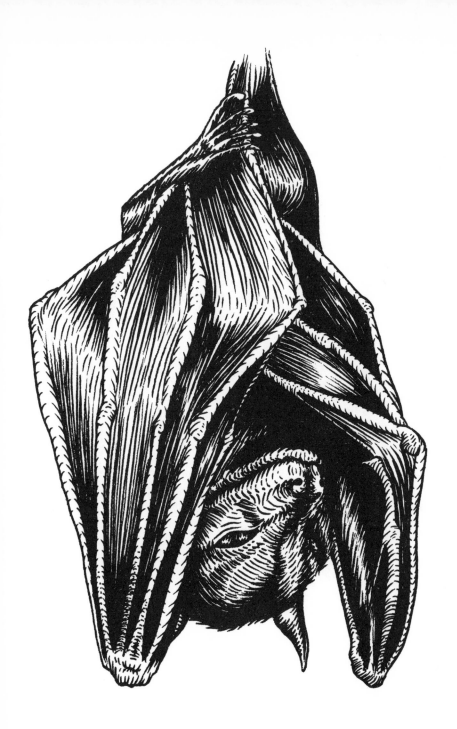

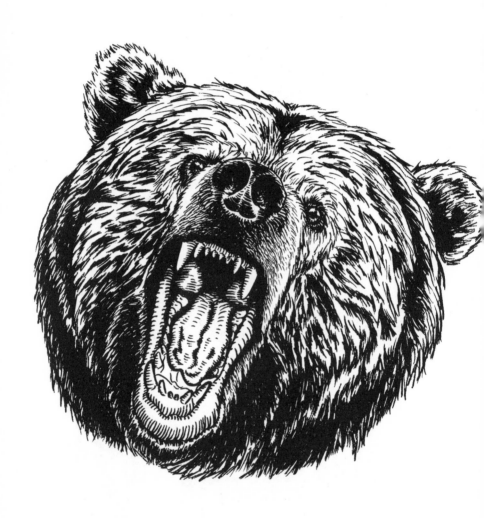

SEE ALSO
Totem *p222*

Bear

The folklore associated with bears is among
the most ancient, dating back to Palaeolithic
times, from which there is surviving evidence
of bear clans. In subsequent times, evidence
for the ritual burial of bears and reverence for
bear remains have been found throughout the
world. The Celts worshipped the bear goddess
Artio and would often have their own family
bear totems, something that lingers to this day
in surnames such as McMahon, which means
"son of the bear". In Native American cultures,
the bear is one of the most powerful totems
and is said to be the keeper of dreams, perhaps
because the animal hibernates once a year. The
infamous Viking berserkers (the name itself is
a Norse word for "bear shirt") revered the bear
for its strength and fury, and would often dress
themselves in bear skins, eating hallucinogenic
mushrooms to work themselves into a frenzy
before entering into battle. In more modern
times, the bear is still a strong part of our literary
mythology, featured in fictional tales such as
Rudyard Kipling's *The Jungle Book* (1894) and
Philip Pullman's *Northern Lights* (1995) as well
as, of course, in young children's stories about
Winnie the Pooh and Paddington Bear.

SEE ALSO
Ouroboros *p158*

Bee

There are few insects in the animal kingdom that
are looked on as favourably and positively as the
bee. Attributes such as hard work, willpower,
and resilience sum up this little creature. It is
easy to see why people in ancient cultures looked
upon the seemingly tireless bee as a messenger
between mortals and the gods. Egyptians
believed that bees were born from the tears of

their sun god, Ra, and many Middle-Eastern cultures viewed the bee as a symbol of eloquence and intelligence. In Hinduism, Kama, the god of love, has a bowstring made of bees, while Brahmari is the goddesses of bees. Christianity also revered the bee as a symbol of Christ, honey being his mercy, the sting his justice. So popular is this little winged insect that you do not have to travel far through any country's culture before this humble creature makes an appearance.

Beetle

See "Scarab Beetle".

SEE ALSO
Barcode *p25*

Binary

Every single electronic device we use – from washing machines to laptops – works on a simple mathematical system – binary. The basic format of binary is that every bit of information is simplified down to either an "on" position (1) or an "off" position (0). Though we think of binary as a modern invention, this coding format was in use long before computers were invented. The Aborigines of Australia are known to have counted in twos, and many African peoples communicated across vast distances via drumming, alternating between high and low pitches (1 and 0, effectively). Because of the computer-driven world we now live in, binary has become popular within tattooing. It is fairly easy to spell words and phrases using binary, only showing as a row of 1s or 0s, and this appeals to the followers of a subculture as it means that only the "initiated" (in this sense someone who is computer-literate) can read the code and therefore unlock the secret held within.

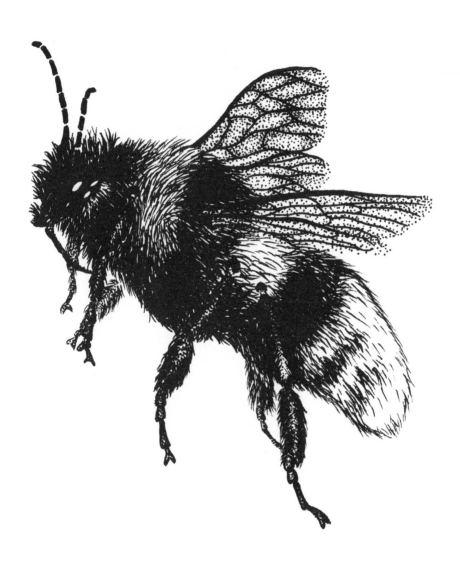

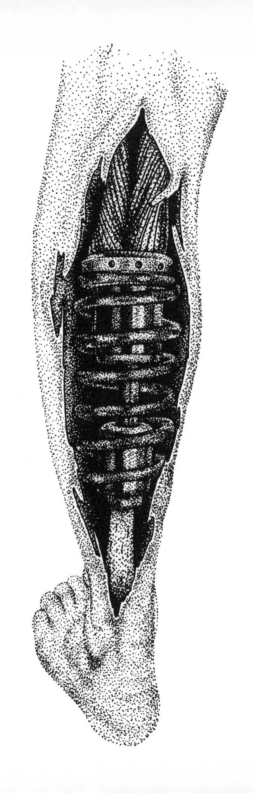

Biomechanical

Biomechanical, or "biomech", is a style of tattooing whereby the tattoo is designed and placed in such a way that is appears that, under the skin, the wearer is part mechanical, digital, or electronic, or composed of organic, alien material. Influenced heavily by the art of the Swiss surrealist H R Giger (1940–2014), biomech made its way into the tattoo world in the 1990s through the work of tattoo artists like Guy Aitchison (1968–) and Aaron Cain (1971–), both of whom are now considered the forefathers of the style. There are certain basic elements that make a piece biomech, namely, that the design takes the human form and twists it so that it appears as if the underlying human structure (muscles and bone) of the area being tattooed has the added element of alien matter (electrical or mechanical), therefore creating a tattoo that is part human and part machine. Design-wise, sometimes the skin appears torn, or cut, to reveal what lies underneath, while in other designs the tattoo appears to sit on top of the skin, the artist using the wearer's musculature and symmetry to create the illusion that the whole tattooed area is composed of parts usually alien to the human body. Many artists will use natural forms and features such as the weather-beaten surface of rocks to create an even stranger, alien surface underneath the skin.

Bird

Not only is the bird a symbol of grace and beauty but it is an image that seems to eloquently express freedom in all its forms; after all, what other creature can walk on the earth, swim in the sea, and soar through the skies? In addition,

because of their seemingly endless variety of shape, size, and colour, more than any other creature the bird is easily adaptable to a wide range of personal associations. Birds feature prolifically in folklore, mythology, and belief systems, their symbolic meaning ranging across the whole spectrum of good and evil, depending on the culture and species. Whether we love them because, while on the wing, they are so expressive of freedom, because of their ancient associations with festive or special times of the year, such as the robin at Christmas, or purely because of their colourful beauty and charm, birds will always be a popular motif across all artistic media.

Birdcage

SEE ALSO
Bird *p33*

As a representation of personal freedom, or lack thereof, birdcages are often a popular design choice. A cage with a bird still in it speaks of a caged spirit, unable to break free of that which surrounds it, whether that is understood on a physical or spiritual level. A cage shown with a bird still in it but with the door open, or the bird set free beyond the cage's confines, shows that these binds have been broken and that one is free of past ties, no longer trapped within the cage. Not only does this image seem to resonate with many people but, because both cage and bird can be illustrated in a multitude of ways, from the elegantly realistic to the heavily stylized, it is an aesthetically beautiful image in itself.

Black-and-grey

SEE ALSO
Blackwork *p36*
Illustrative *p108*
Neo-traditional *p152*
Realism *p179*
Trash Polka *p222*

Falling into a similar category to realism, black-and-grey tattooing attempts to recreate realistic imagery, but using only black ink.

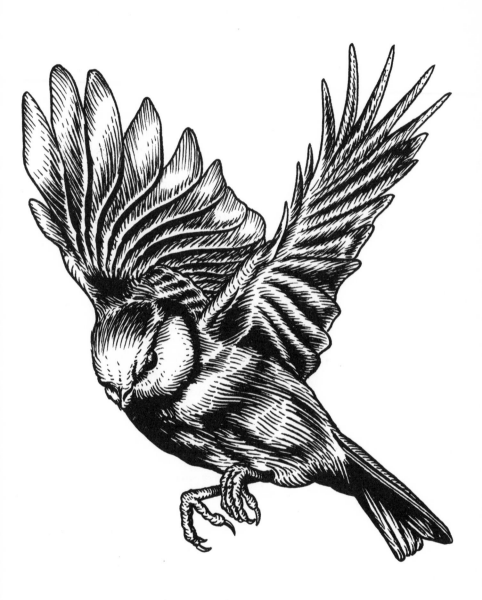

As with realism, shading and contrast are extremely important in black-and-grey and there are no black bold "outlines". In order to achieve the different tones needed in black-and-grey, an artist usually mixes black ink with water or white ink. For example, an artist may have ten ink cups and start with purely black ink in the first and water it down a few drops per cap until the tenth cap, which will be almost white or even pure white. Nowadays, ink companies make grey-wash ink sets, which means that artists do not have to dilute their own ink. Though the style is called black-and-grey, many artists use white as a highlight, to make the tattoo stand out more, or to accentuate certain features or objects within the tattoo.

Blackwork

Blackwork is a style that, as the name suggests, comprises solely of designs executed with black ink. Unlike black-and-grey, where the focus is usually on realistic designs, blackwork is more abstract, the artist using lines and geometric patterns to create the overall look. Blackwork tattoos are very ornamental, often covering large areas of the body, and there is not always a discernible meaning behind the tattoo; more often than not, the tattoo is designed purely for aesthetic reasons. Blackwork more than likely evolved out of tribal tattoos, but whereas tribal styles traditionally relied on thick black lines and patterns, blackwork is more subtle, the line-work thinner, more intricate, and more decorative. Blackwork is often fused with dot-work, as the two styles complement each other well, not only in terms of how they look, but also in terms of the elements and motifs they use.

SEE ALSO
Dot-work *p66*
Irezumi *p111*

Bodysuit

A bodysuit is a tattoo that covers the entire body and is usually in one particular style or pertains to a single theme. Bodysuits are most commonly associated with traditional Japanese-style tattooing, where the back piece is the central focus of the suit; this is because this is the biggest area that can be seen at once, the artwork stretching from the neck, down the back, to about an inch below the buttocks. Traditionally, the rest of the body is then tattooed with images, or themes, that support the back piece. The important element with Japanese bodysuits is that all the separate parts of the body – arms, chest, and legs – complement one other and are linked. This is usually done using the background or else a common theme. A bodysuit, when viewed as a whole, should tell a story. Though a collector might get a single artist to complete the whole suit, it is not uncommon for different artists to tattoo different areas. This is an accepted practice among top Japanese-style tattooists, as many of the artists at the top of their craft respect one another's artistry and consider it an honour to be represented together in a full bodysuit.

SEE ALSO
Endless knot *p74*
Fu dog *p93*
Lotus flower *p130*
Tree of Life *p225*

Buddha

One of the most popular, or most represented, images in all art media, whether in the East or the West, is "the one who is awake", the Buddha. According to Buddhist scriptures, Gautama Buddha was born some 2,500 years ago, a simple man who had no aspirations to being a prophet or a god but who, through enlightenment, began to see the world and understand life in the deepest possible way. Born into a royal family, and used

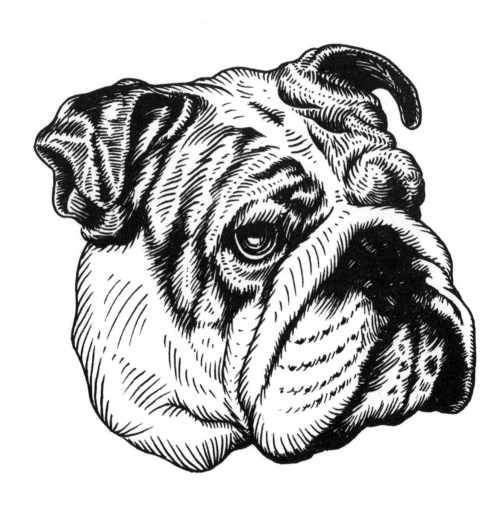

to a life of luxury and ease, he ventured into the city and what he saw there – old age, sickness, and death – caused him to question the true meaning of life. This started the spiritual journey that ended with him becoming enlightened while sitting under the Bodhi ("Enlightenment") tree. Buddha then spent the next 45 years spreading his teachings. Today, Buddhism remains a major world religion and is followed by people in all countries and from all walks of life. Whether he is shown as a young man on a quest or as the laughing pot-bellied master of enlightenment, the image of Buddha is an image that invokes love, enlightenment, understanding, and peace.

SEE ALSO
"Death Before Dishonour"
p60
Eagle *p73*

Bulldog

Though often associated with Britain, where it is often used as a symbol of national pride and heritage, the bulldog is also linked to the United States and to its military. Its roots in the psyche of the British people begin in the eighteenth century, when the bulldog was often depicted accompanying John Bull (a mythical personification of Britain, similar to the United States' Uncle Sam) and then later associated with the wartime Prime Minister Winston Churchill (1874–1965). Both John Bull and Churchill were popular figures in their time, and therefore the bulldog quickly became a symbol of British patriotism. In the United States, the bulldog's origin in tattooing can be dated back to the early 1900s and the US Marine Corps. One of the first unofficial mascots adopted by the Marines was an English bulldog named King Bulwark. More commonly known as Jiggs, the bulldog was actually enlisted into the Marines by Major General Smedley Butler (1881–1940). Folklore has it that, during the First World War, members

of the German forces would call the attacking Marines *Teufelshunde*, meaning "devil's dogs". The story stuck and from then on, within the United States, the English bulldog has been closely linked to the US Marine Corps and is widely used in military tattoos.

SEE ALSO
Owl *p161*
Skull *p198*
Wings *p238*

Butterfly

Because of its seemingly near-miraculous ability to change its form completely, the butterfly has always been prominent in folklore and mythology. In its simplest form, the butterfly is a symbol of transformation, renewal, and resurrection, but has also been associated with the soul in many cultures. The ancient Greeks depicted the soul (*psyche*) as a butterfly, and in Christian art Jesus was often shown holding a butterfly on carvings and tombs. Some of the most striking butterfly designs were created by early tattoo artists, who would often work symmetrical images such as skulls, owls, and gypsy women's faces into the wings. Nowadays, because of the myriad of colours and forms they can take, butterflies are often chosen purely for their aesthetic appeal.

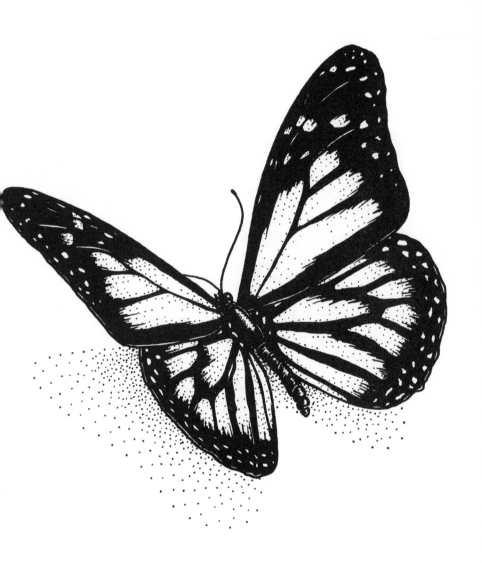

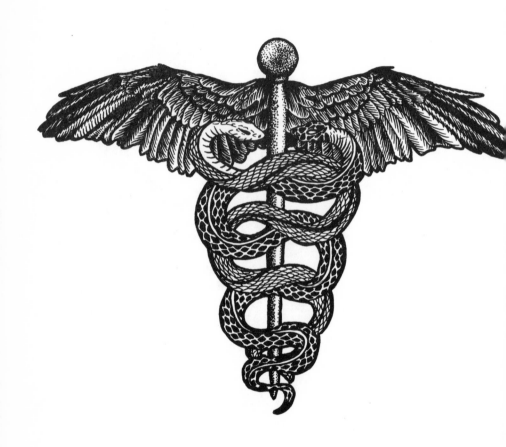

Caduceus

In ancient times the caduceus was an emblem used in association with commerce. The design, made up of two snakes entwined around a winged staff, was the symbol of Hermes/ Mercury, the messenger god and god of trade of the ancient Greeks and Romans, who was often depicted bearing it in his left hand. The design was originally rendered as a herald's staff with white ribbons wrapped around it, but over time it has changed into the image we know today. The two snakes represent the joining together of two separate realms, working towards a common goal or reward. Quite often, the caduceus is mistaken for the globally used medical symbol, the Rod of Asclepius, which is comprised of a single snake wrapped around a staff. Typically, the caduceus has been used in a heavily stylized form, but in modern tattooing the meaning associated with it has been set aside and the design is often reworked into a much more realistic illustration, making it a striking and powerful motif.

Candle

Candles feature in many old tattoo flash sheets from the early days of tattooing. A quite literal symbol, the candle represents finding our way

in the dark, or even just a light in our darkest moments. Candles would have been very rich symbols for early sailors and explorers, before the advent of electricity. Of course, candles have also long been associated with religious rites and sacred places, and therefore are linked to spirituality – a symbol of light on the road towards higher enlightenment and peace. Amnesty International successfully harnessed the symbolic meaning of the candle by using it in its logo. A lit candle surrounded by barbed wire, it is their motto visualized – "It is better to light a candle than to curse the darkness."

Cartoons

See "Anime", "Kawaii", and "Manga".

SEE ALSO
Bast *p25*
Maneki-neko *p133*

Cat

The cat has always been a popular motif in tattooing. Many old flash sheets have designs featuring cats, often as symbols of good luck because of the cat's popularity among sailors. In the early days of sailing cats played an important role on board ships, where they were kept to kill vermin such as rats, which had the potential to spread disease and ruin precious cargo. Cats are revered in many parts of the world and can be found ingrained in the culture and mythology of most countries; in Japan, for example, they are viewed as almost sacred creatures. The duality of the cat's personality – at times sleek, graceful, and independent; at others skittish, mischievous, and almost comical – makes them easy to anthropomorphize, and it is this quality that not only makes them one of the most popular of household pets, but also a popular subject in art and tattooing.

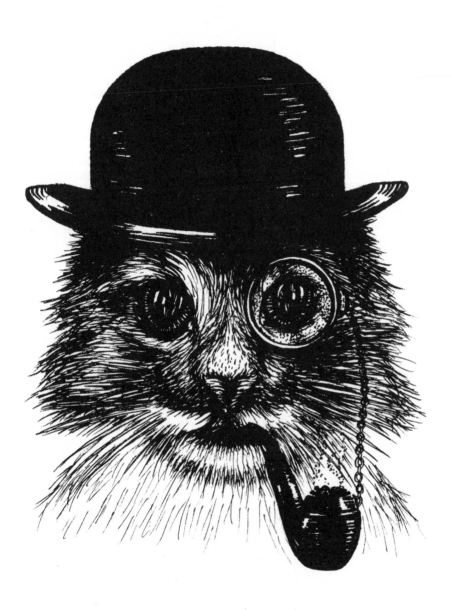

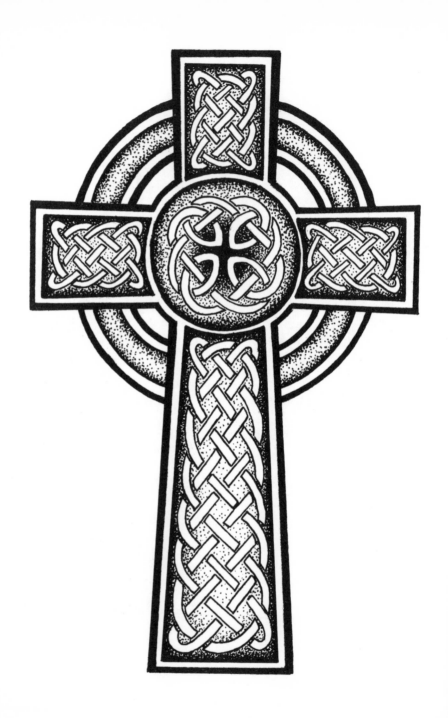

SEE ALSO
Triquetra *p226*

Celtic cross

A design that reaches far back into antiquity, the Celtic cross has long been used as a symbol of Irish heritage and culture. The basic form of this representation is a cross with a circle around the centre intersection (nimbus), with the lower arm (or stem) being significantly longer than the three others. The cross is often decorated with elaborate interlocking patterns and other Celtic motifs. Legend has it that the cross was introduced to Ireland by Saint Patrick while visiting on a mission to convert the local pagans to Christianity in the fifth century. In order to do this, Saint Patrick added the circle (nimbus) to the Christian cross, as some of the Irish at the time worshipped the sun. Despite this heritage, there is no definitive meaning behind this ornate motif; rather, it has become open to individual interpretation.

SEE ALSO
Mandala *p133*

Chakra

Within some Indian religions it is believed that chakras are energy points located at specific positions on the body. The word *chakra* is Sanskrit for "wheel" or "cycle" and, though there are many of these points found on the human body, there are seven that are said to be the most important. These seven chakras run the length of the spine, starting just above the head and ending at the coccyx. It is thought that when these specific chakras are "out of alignment", or when the body's energy is not flowing through them unhindered, a person's spiritual and physical well-being is negatively affected. Practices such as yoga and meditation will realign the chakras, restoring the flow of the body's energy, and thus an individual's spiritual

and physical well-being, too. Western New Age traditions now assign colours, as well as crystals, to these seven chakras and these have become popular designs within tattooing, the chakras being tattooed in their corresponding positions along the body.

Cherry

SEE ALSO
Apple *p21*

There are a few tattoos that are purely seen as sexy, and the cherry is one of those. Though there are no doubt various associations and meanings behind the cherry, within tattooing it is nearly always chosen because of its associations with feminine sexuality, fertility, and desire. The cherry's vibrant red colour, its taste and texture, and its visual appearance have done more for how we view the cherry, symbolically, than any story within myth, legend, or folklore – ancient or modern. It has a duality that calls to mind both a playful innocence as well as more passionate, carnal desires, its ambiguity constantly treading a fine line between purity and hedonism.

Cherry blossom

SEE ALSO
Anime *p20*
Manga *p135*

The cherry blossom, or the *sakura* as the Japanese call their national flower, is often found in Eastern designs and art, and is a very popular motif in tattooing, not only within Japanese styles, but also as stand-alone flower pieces. This small pink-and-white flower is a symbol of life and hope for the Japanese, whereas in China it is linked to female sexuality and authority. The cherry blossom's "life" is short – it blooms and then quickly falls from the tree – and therefore Buddhists see it as a reminder to live in the present moment. Cherry blossoms have a deep symbolic resonance for Asian cultures and they

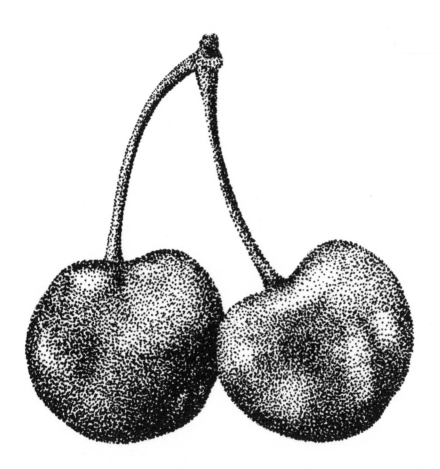

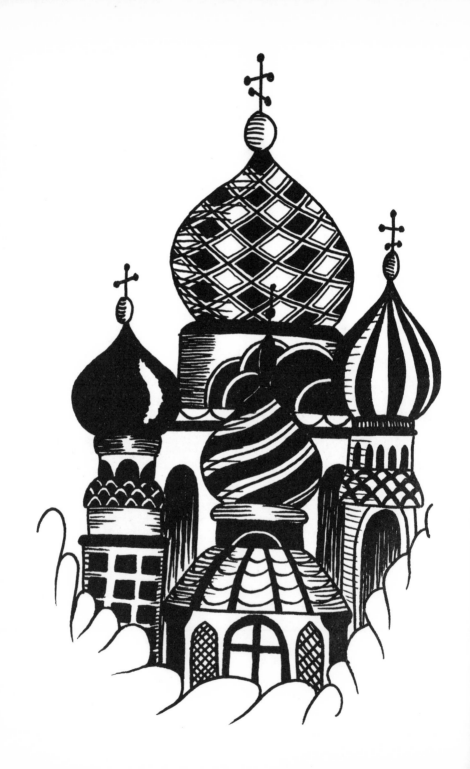

can be found not only in complex tattoo designs and fine art but also in popular art forms such as anime and manga.

Church

Setting aside any strong religious reasons for someone choosing to get a church-themed tattoo, in the Russian prison system a tattoo of a church has rather more secular connotations. Often tattooed on the chest, back, or hand, the church for these inmates stands for time served and whether or not that sentence has been completed. The number of spires on the church can either represent the number of years being served or the number of times the criminal has been to prison. Often, once a sentence has been served, a cross is placed on top of, or across the top of, the spires to show that the individual's debt to society has been paid. In some cases, the church is replaced with a fortress or mosque.

Circumpunct

This simple symbol, a circle with a dot in the centre, has been found all over the world and throughout history. It is one of the oldest symbols known to humanity and is still popular today. To Greek philosophers, it was said to represent God – the point at the beginning of creation and also all eternity. For many cultures it represents the sun, while in alchemy it is the symbol for gold. Many see the circumpunct as a symbol of themselves (the dot) and the universe (the circle) that surrounds them; we are one with everything and everything is one with us. Within the esoteric arts, this powerful symbol is often found nestled among bigger motifs, a small reminder of our place in the great scheme of things.

Claddagh

The claddagh is a traditional Irish ring that is given as a token of love, loyalty, or friendship and is composed of two hands (representing friendship) holding a heart (love) surmounted by a crown (loyalty). There are many stories about the origins of the ring's design, but what we know for sure is that it has been made in Galway continuously since the 1700s, even though the word "claddagh" itself is not attested before 1830. There are many localized traditions about what the wearer is seeking to express by the way in which they wear the ring – for instance, whether the point of the heart is facing towards the fingertips or the wrist, or on which hand the ring is worn – but traditionally the claddagh has been given as a wedding or engagement ring. The design has become so popular that it is now seen in many other settings and it has become a popular tattoo motif.

Clown

Though many people will get a clown tattoo purely because of the aesthetic value they see in this design, clown faces have a long history within gang culture. Clowns are said to represent gang life and are often accompanied by the words "Smile Now, Cry Later". While these gangster clowns are often heavily stylized, they still retain a realistic appearance, making them seem almost like caricatures. Another popular motif is the Clown Girl, or Payasa Girl, which is also done in a realistic style. This design is of a beautiful woman with her face made up to look like a clown's. *Payasa* is Spanish for "clown". Clowns have also become popular because of their connections with horror movies: the idea

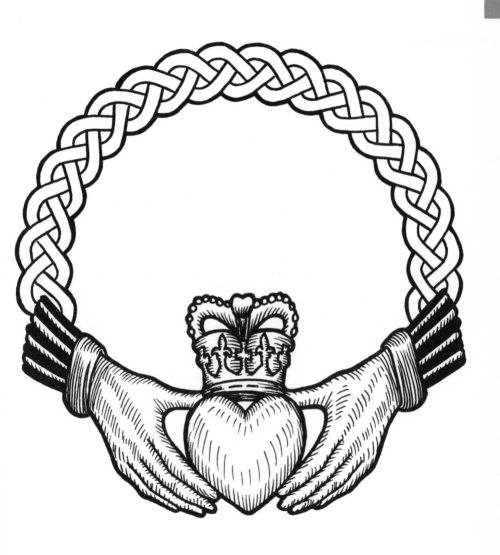

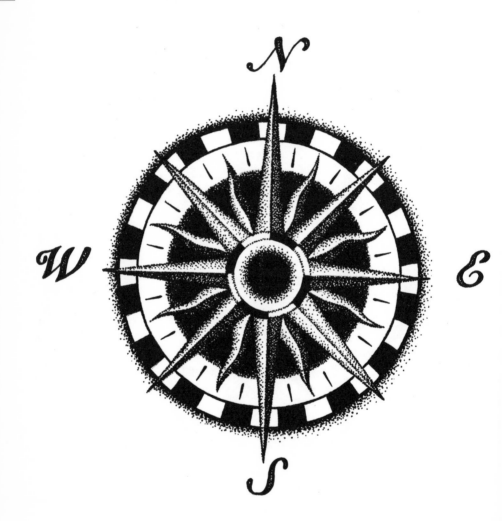

of something that is supposed to make you laugh
actually being intrinsically evil clearly strikes a
chord among fans of the genre.

Compass

Besides the literal interpretations of the
compass – those of having direction, guidance,
and staying your course no matter how rough the
weather – the compass is also symbolic of these
things on a spiritual level. Sailors would often
get a tattoo of a compass for these very reasons, a
token of good luck and safe passage while sailing
the seas. It was also seen as a token of protection,
some ships even having the compass painted on
their bows. The compass comes in many forms
and interpretations, but one of the most popular
is the North Star compass, based on the idea that
it was the North Star that would always guide
sailors home, no matter where they were in the
world. Nowadays, these beliefs still hold true
for this symbol, as well as it being a reminder to
always follow one's dreams.

Cover-up

A cover-up is when an artist places a new tattoo
over an old one, thereby covering it up so it can no
longer be seen. Historically, cover-ups could be
ugly and messy, and the old tattoo could often be
seen under the new one. There is many a person
walking around with a solid black sleeve covering
up old tattoos that they no longer want. However,
as techniques and technology have advanced, the
artistry of cover-ups has increased, and now it
can almost be considered a style in itself. There
are many clever techniques to achieve a quality
cover-up, and an artist specializing in this field
will be able to do a cover-up in such a way that it

would be extremely hard to tell that there is an old tattoo under the new one. Often, an artist will incorporate the old tattoo into the new, so that the two work together or complement each other; this is often done when a client has an old tattoo they do not want to get rid of but want to use the area more effectively or to update the old tattoo. An artist known for doing on-point cover-ups will often be sought out purely for this skill.

Crescent moon and star

The symbol of the crescent moon and star has been used since antiquity, the ancient Greeks, for example, associating it with the huntress goddess Artemis. However, it was in the Near East that it was most widely used. During the Crusades of the Middle Ages, the flags of the Muslim armies often showed a crescent moon, the star being added only rather later. In the nineteenth century, the crescent moon and star was adopted as a national symbol by the Ottoman Empire and has since been included on many national flags. From the 1950s and 1960s onwards, the symbol came to explicitly represent Islam and Islamic nationalism in the Muslim community.

Cross

See "Celtic cross", "Jerusalem cross", "Leviathan cross", "Pachuco cross", and "Quincunx".

Crow

Many cultures look on the crow as one of the keepers of sacred and ancient law, and these

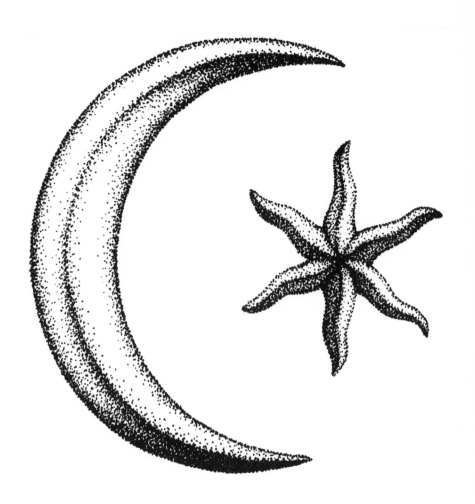

intelligent birds are often associated with magic and life mysteries. Depending on the culture, the crow can be seen as a portent of bad times or as a sign of good fortune. Because they are carrion birds, in that they usually feed off dead animals rather than hunt live ones, they are often found around battlefields and other areas where death has occurred, earning them the reputation as travellers between our world and the next. The Scottish have a saying, "Up Crow Road", an expression for death, and Hindus believe that crows bring offerings on the anniversary of a relative's death. Aside from the myth and folklore, the very nature of the crow – its bold, swaggering demeanour and its loud, abrasive call – has earned it a place alongside the coyote as one of the trickster animals, always up to mischief and up for causing trouble. Yet these same qualities, when interpreted slightly differently, can cast the crow in a different light – as a strong, fearless creature, unafraid of life's dangers and happy to take a risk for what it wants.

Crucifix

See "Jesus".

Cthulhu

A cosmic entity created by the US fantasy writer H P Lovecraft (1890–1837), Cthulhu is part octopus, part man, and part dragon. It is theorized that the name, invented by Lovecraft, is derived from "chthonic" – from the Greek word for "subterranean" – used to describe spirits or deities of the underworld. In most depictions of Cthulhu, he has the head of an octopus, with numerous tentacles hanging from his mouth; sometimes he is shown as winged. In

Lovecraft's short story, "The Call of Cthulhu" (1928), this evil and malevolent creature lives imprisoned beneath the sea, biding his time as he builds an army and prepares to escape back to land to seek revenge and power. It is believed that Lovecraft may have based Cthulhu on the ancient Celtic water spirit Coinchenn, a fearsome female monster who lived beneath the waves, protecting her daughter from her suitors.

D

60

SEE ALSO
"Death Before Dishonour"
below

Dagger

From prehistoric times on, the dagger, or short-blade knife, has been at our side, not only as a means to hunt, feed, and clothe ourselves, but also as a means of protection and attack. The dagger holds a special significance in our psyche as, of all weapons, it is the most personal – the person wielding it has to be in near physical contact with his or her target. This intimacy would suggest that the two players involved in the conflict know each other, and so it can also become a weapon of betrayal. On the other hand, it can also be seen as a symbol of bravery, as close-quarters fighting is more dangerous than dispatching someone from afar. As a symbol, the dagger is thus ambiguous, suggesting stealth, cunning, bravery, betrayal, treachery, and deception.

SEE ALSO
Bulldog *p39*
Dagger *above*
Eagle *p73*
Old school *p155*

"Death Before Dishonour"

A motto used by military personnel as far back as the ancient Romans, Death Before Dishonour is a popular symbol that means that one would rather die than lose face or bring shame upon one's name, military unit, or loved ones. Though the motto is now most commonly associated with members of the US Marine Corps and has long been a popular traditional tattoo for

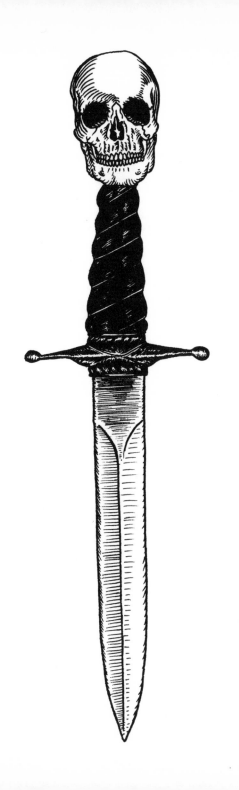

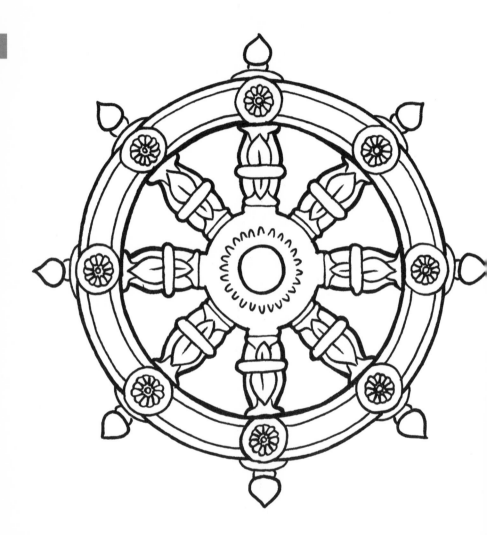

anyone serving in the military in the West, the concept can be found in many other cultures: the samurai of medieval and early-modern Japan, for example, would rather kill themselves than surrender to, or be captured or killed by, the enemy. As a tattoo, it is usually rendered in the old-school traditional style using bold lines and bright colours, the motto written on a scroll that is usually wrapped around a dagger piercing a heart. Because of its military associations, an eagle is often incorporated into the design.

Demon

See "Oni".

Dharma wheel

One of the most ancient Buddhist symbols, the dharma wheel (*dharmachakra*) is now commonly used to represent Buddhism in the same way that the cross is used to represent Christianity, or the Star of David is used to represent Judaism. A dharma wheel (often depicted as a chariot wheel) has three basic parts – the hub, the spokes, and the rim. The rim of the wheel represents meditative concentration and mindfulness, a core principle of Buddhism that holds all its teachings together. The hub symbolizes moral discipline and often contains three swirls, representing the Three Treasures, or Jewels, of Buddhism. The spokes can vary in number and as such can represent different aspects of Buddhist teachings. A design with four spokes symbolizes the Four Noble Truths, while a wheel with eight spokes relates to the Eightfold Path. The dharma wheel is usually very colourful and is often depicted alongside other symbols of Buddhism, such as the lotus flower and deer.

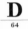

Die/dice

A symbol for luck and a metaphor for life, dice are representative of how we sometimes perceive life to be. We throw the dice and our fate is revealed; we have no more control over the result than we have over what tomorrow will bring. Because dice have historically been used for gambling, they can also be representative of a gambler or risk taker – someone who will make decisions based on the "roll of the dice". When tattooing a pair of dice, it is common to use three and four dots on the visible faces to make a total of seven. This is because the number seven is seen as a symbol of good luck or good fortune, and in the dice game Craps a throw of seven will win. Dice adding up to 11 are sometimes used for much the same reasons, but this is not as common.

Dionysus

Also commonly known by his Roman name, Bacchus, Dionysus is a powerful masculine image of hedonism and living to excess. Originally the Greek god of wine, fertility, and nature, he is also associated with mystery religions, a symbol of spiritual enlightenment sought beyond the daily world and of initiation into secret rites through intoxication of the spirit. Because, according to Greek mythology, Dionysus was born twice, having being brought back from the dead by his father, Zeus, he is also associated with rebirth. This is perhaps one of the reasons he is associated with wine, as grape vines are pruned right back for the winter but, when summer returns, spring to life, to once again bear fruit. To this day, once a year in early spring, festivals are held in honour of Dionysus.

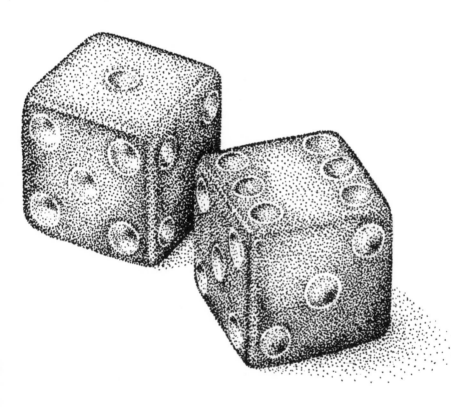

Dots

See "Three Dots".

Dot-work

Though it may seem as though dot-work is a fairly recent development in tattooing, it is actually one of the oldest methods of getting ink into the skin. Before the invention of the electric tattoo machine, most tattoos were applied by dipping a sharp instrument into ink and then puncturing the skin to deposit the ink underneath. This method was done by hand and is the reason why sometimes dot-work tattoos are called "hand-poked" tattoos. In recent years, artists have been using tattoo machines to do dot-work, a method that has speeded up the process, which in turn has allowed for bigger designs. The central design element of dot-work tattoos is that the tattoo is composed entirely of single dots; no lines or black fill are used. Much like how a dot matrix printer works, shading is achieved by increasing or decreasing the density of dots in a specific area, depending on how dark or light that area needs to be. Dot-work tattoos tend to have geometric themes, though this trend is quickly expanding so that other images generally seen in other styles, such as old school and realism, are being incorporated into dot-work. Similarly, black has been the main colour associated with dot-work, but this has now expanded so that some artists are now using full colour palettes.

Dove

Stereotypically, the dove is seen as a symbol of peace, love, and purity. It is deeply associated with Christ and Christianity, and its appearance

in the Bible is always within the context of a
message from God or the presence of the Holy
Spirit. A dove returned to the ark with an olive
branch in its beak, to assure Noah that land,
and therefore safety, was at hand, and in art
it is used to represent the descent of the Holy
Spirit during the Annunciation to the Virgin
Mary as well as at the baptism of Jesus. It is
said that the dove is so pure that it is the only
creature on earth that Satan cannot assume
the form of. The dove is also associated with
love and was a symbol of Aphrodite and her
Roman counterpart, Venus. These qualities
are so engrained in our perception of the dove
that it has become a worldwide emblem of peace,
used by many pacifist groups as a symbol for their
belief system.

Dragon

There are very few world cultures that have not
revered, or feared, dragons in their mythology
or legends. Dragons have long been popular
in art and literature, but to the Japanese the
dragon (*ryu*) is not the fire-breathing terror
of the European or Western imagination. For
the Japanese, the dragon symbolizes wisdom
and strength, as well as being the protector and
guardian of human beings on the earthly
plane. Dragons in the West were envisioned as
reptilians with wings and four limbs, while in the
East they were wingless and snakelike. Within
the Asian culture of tattooing, dragons can vary
greatly from artist to artist and often their faces
will be a combination of many different animals',
while still retaining the wingless and snakelike
body. Another important aspect of Asian dragons
is that they will often be depicted clutching a
sphere, jewel, or orb (the closed lotus form) in

one of their claws. This is meant to represent the essence of the universe that the dragon is able to control and manipulate, and is a motif that can often be seen in Buddhist temples. Though Chinese and Japanese dragons can seem similar, one of the ways of telling them apart is by their claws: Chinese dragons usually have five claws while Japanese have just three. Because dragons have been so strongly linked with Japan and China, in the naval context a dragon tattoo was used to represent a sailor who had served in Asia. Dragons are also featured in the mythology of the British Isles, most notably in the legend of Saint George and the Dragon, and is thus a popular choice as a means of showing patriotism and heritage; the red Welsh Dragon serves a similar function. The colour of a dragon, whether it has horns or not, and what form it takes, all have various meanings, and it is therefore important to know such details when choosing a design.

SEE ALSO
Dragon *p67*
Snake *p201*

Dragonfly

For the Native Americans, the dragonfly was a healing animal, associated with medicine and transformation. Often, during healing rituals, medicine men and women would call upon the dragonfly to aid them. The dragonfly can be found in many mythologies and is usually viewed as a symbol of change or transformation. It can also be a symbol for water, as in Navajo sand paintings. In medieval Japan, the samurai associated the dragonfly with power, agility, and victory, while the Chinese viewed it as a sign of good luck and harmony. In Welsh mythology, the dragonfly was called the "snake's servant", as they believed that the dragonfly followed snakes around, stitching up their wounds.

SEE ALSO

Bear *p29*

Feather *p80*

Sun *p208*

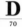

D

70

Dreamcatcher

Originating in Native American culture, the dreamcatcher is a hoop made of willow that is then decorated using sacred objects such as feathers and beads. The circle, or hoop, is a powerful symbol in some Native American traditions, where it is seen as a sign of strength and unity; in others, the hoop is representative of the sun and the moon, and their journey across the sky. The hoop is woven with a fine net, or web, with a small circle in the centre. The purpose of the dreamcatcher is to let the "good dreams" pass through the centre, while the "bad dreams" are trapped within the net. When dawn breaks, the bad dreams that have been caught within the dreamcatcher are destroyed by the rising sun.

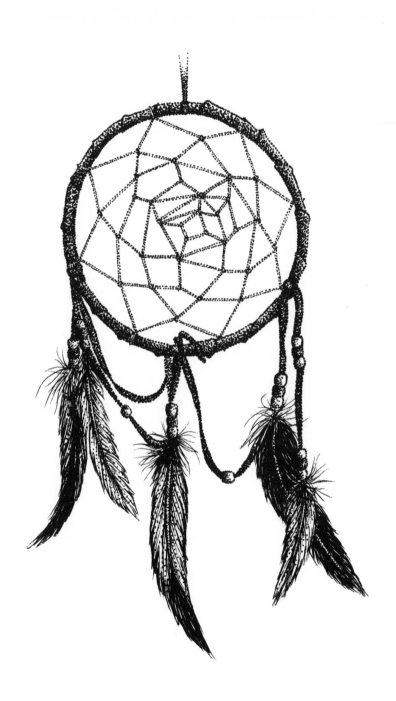

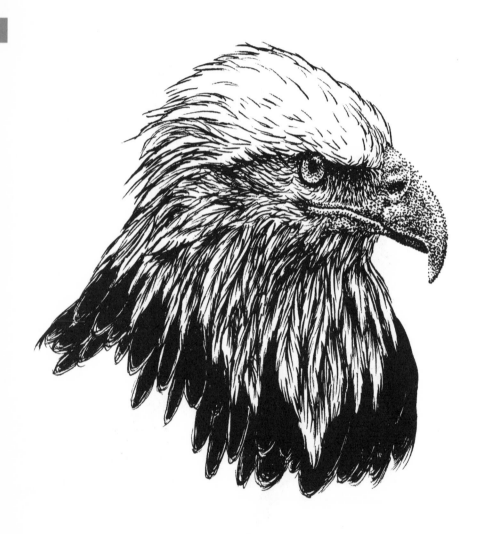

Eagle

Most commonly associated with the United
States, especially the US Marine Corps, where
it is incorporated into the insignia along with
a globe and an anchor, the eagle – as a symbol of
strength, freedom, wisdom, and power – has
been in use for centuries. In religion, the eagle
has often been associated with the sky god – often
the most important deity. The ancient Greco-
Roman god Zeus/Jupiter had his own eagle,
named Aquila, who carried his thunderbolts and
his messages, and sometimes took the form of an
eagle himself, as in his abduction of Ganymede.
Whenever the symbol of the eagle is used, it is
to show power or dominance. But not only is it a
sign of brute strength, but also of knowledge and
foresight, and the power that comes with those,
too. In Freemasonry, a double-headed eagle is
used as a sign of the union of opposites.

Eight-ball

The eight-ball is a common element in many
traditional old-school tattoos and is still widely
used in modern tattooing. The eight-ball is often
used as part of a larger motif, shown alongside
other gambling tools such as dice and cards. It is
uncertain why the eight-ball is used as a symbol
of good luck but it could be due to the fact that,

within the game of pool, the eight-ball is the last ball to be pocketed and wins the game; if a player is unlucky and it is sunk before the rest of the other balls have been pocketed, the game is lost straight away. This could also be the reason why the eight-ball is sometimes used to represent a person who is a risk taker, someone who is willing to take a chance to win good fortune. More uncommonly, the eight-ball is also used to show that a person is a drug user, as an eight-ball, in drug terminology, is an eighth of an ounce of cocaine.

Endless knot

In Buddhism, the endless knot is a motif depicting intertwined lines without beginning or end, symbolic of the Buddha's endless wisdom and compassion. In its earliest forms, the "Glorious Endless Knot" appeared as two stylized snakes. For Tibetan Buddhists, the knot is representative of how everything in life and the universe is closely intertwined, dependent on cause and conditions. Because there are no gaps or breaks within the knot, it expresses motion and rest in harmony with each other. Placing the symbol on a gift or card links the bearer of the gift with its recipient, while at the same time ensuring that the recipient is awarded good fortune in the future, as the future is linked with positive actions in the present.

Eye

Windows to the soul, eyes seem to hold a special place within the human psyche. The most famous eye in iconography is probably the all-seeing eye, or Eye of Horus, an ancient Egyptian design that has long been steeped in mystery and is often

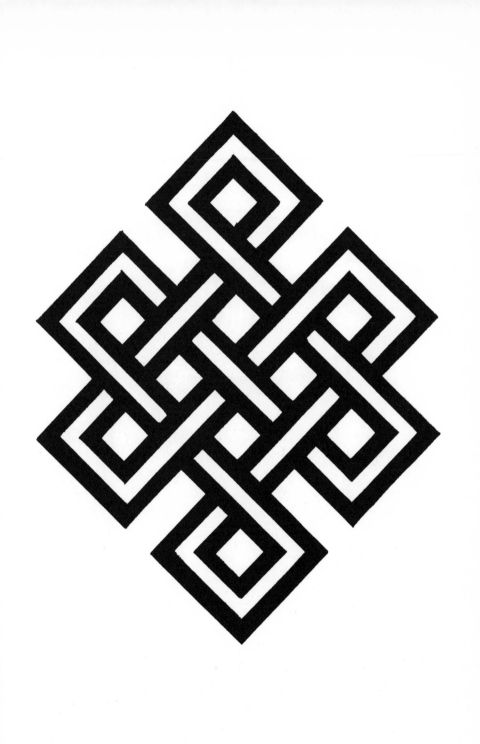

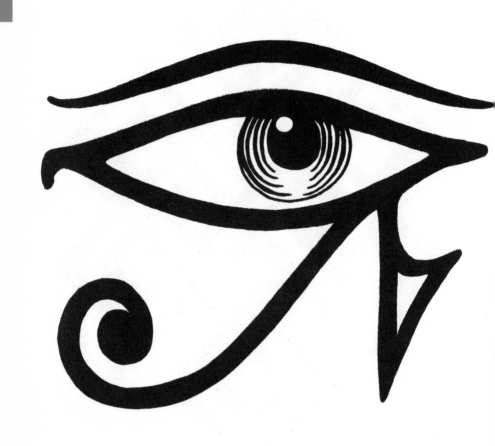

associated with the occult. A popular image in both the artistic and the tattooing worlds, it is a choice for many people who are attracted by its simple beauty and arcane meanings. The Eye of Horus (sometimes referred to as the Eye of Ra) was a symbol of protection and good health, and is found everywhere in Egyptian art. One of the most popular theories surrounding the design is that it was a visual representation of ancient Egyptian fractions, running from the right-hand side of the eye (representing ½) through to the eyebrow (⅛) and the teardrop (1/64).

SEE ALSO
Eye *p74*

Eyeball tattoo

The definition of a tattoo is the insertion of ink into the dermis layer of the skin in order to permanently change its pigment; therefore eyeball tattoos are not technically tattoos, but are nonetheless classed as such. Eyeball, or sclera, tattoos are where ink is injected into the white of the eyeball to change the colour. Eyeball tattooing was first attempted on a healthy-sighted person at the end of 2007 and since then has been performed many times. The procedure itself has been known to cause blindness and other complications, though many people have successfully had the procedure with no lasting side effects. Most tattoo artists will not perform an eyeball tattoo as it is a very risky procedure and the long-term effects are still unknown.

F

Faery/fairy

See "Angel".

Faith, Hope, and Charity ("F.H.C.")

Starting life as a Christian design, the triple motif of anchor, cross, and heart made its way early into the repertoire of tattoo artists and was once a common sight on flash walls. Traditionally, the motifs were said to represent three young girls – Faith (cross), Hope (anchor), and Charity (heart) – martyred in Rome in the early second century AD – who in turn symbolized the "three theological virtues of Christianity". In tattooing, the three symbols generally remain the same through the various designs but, depending on the artist and location, various elements are highlighted or brought to the foreground. Often, the initials F.H.C. will accompany the design, or a banner with the words "Faith, Hope & Charity" will be included.

Father Time

Usually depicted as an elderly bearded man wearing a robe and carrying an hourglass, the idea of a Father Time is common to many cultures throughout history. It is not known

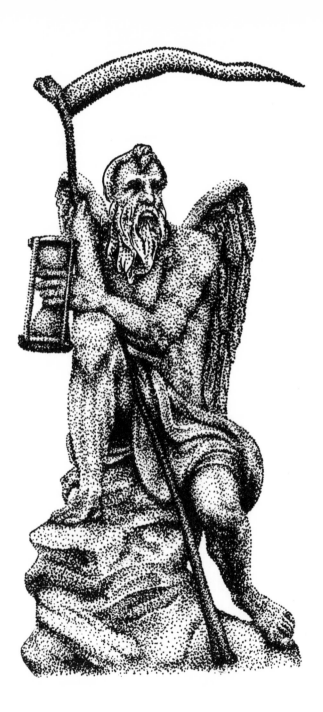

exactly where this image originates, even though the Greeks had a god of time, Cronus. Some cultures link Father Time and the Grim Reaper, both of whom watch over our daily lives, Father Time's hourglass running out as we come closer to death. In Father Time's case, though, as the sand runs out of the hourglass, spirituality (often represented in images by a white or silver light) flows upwards, showing how, even though we may be degenerating physically, our spirit is being renewed.

Feather

Admired as much for their beauty as for what they symbolize, feathers have long been a popular design choice in tattooing. In most mythologies and folklores, the feather is associated with the purity of the heart and soul. In ancient Egyptian belief, Osiris, god of the Underworld, weighed the souls of the dead against the white Feather of Truth, or Ma'at, on a great golden scale: only those that proved lighter than the feather were admitted into the Egyptian "heaven", the Field of Reeds; the rest were thrown to the crocodile god Amenti. For Native Americans, feathers were a powerful symbol that connected them to the spirits of birds. Eagle feathers were given, as a great honour, to warriors who showed the most bravery and courage, and a headdress adorned with such feathers was thus a record of their achievements. Feathers also symbolize the attributes we usually associate with birds – freedom of the mind and heart; our flight through life, and the wings to reach spiritual enlightenment. Modern some of these associations may be, but they have roots in ancient cultural beliefs and folklore.

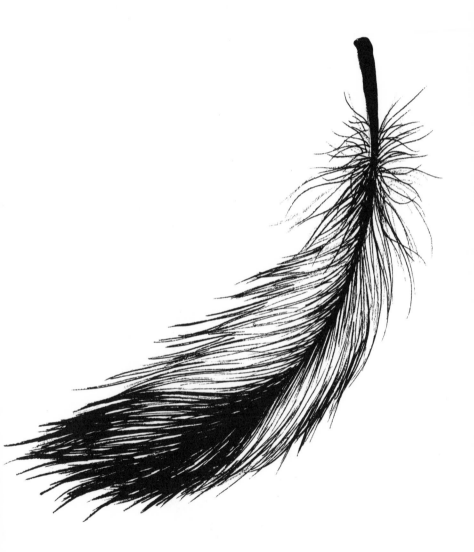

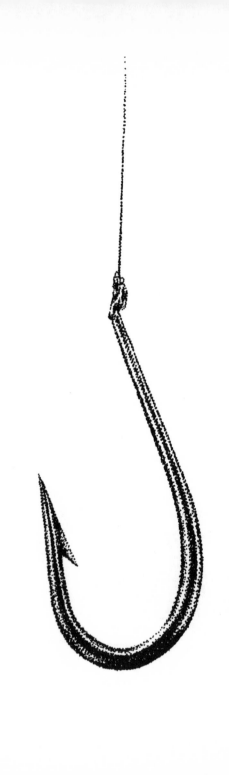

Fingerstache

SEE ALSO
Hot Stuff *p105*

In 2003 a trend known as the fingerstache started appearing within tattooing and soon spread around the world. It is a simple, humorous concept: a stylized moustache is tattooed onto the inside of the index finger, which can then be placed on the upper lip to look as though one has a moustache. Almost as comical as the tattoo itself is the ongoing debate over who first came up with the idea of the fingerstache; the current consensus is that it was one of two tattoo artists, one based in Ohio and one in Rhode Island. The fingerstache is another tattoo in a long line of comic tattoos that has no real merit other than fun. As with all fads, its popularity dissipated just as quickly as it grew and the fingerstache is now seen as representing a moment in time (the rise of the hipster movement and the mainstream popularity of tattooing) rather than as an enduring phenomenon in the history of tattooing.

F

83

Fish hook

SEE ALSO
Maori patterns *p136*
Ta moko *p215*
Tiki *p218*

With any culture that has grown and flourished near the open sea, you will find a rich supply of marine-based myth and folklore. As fish was a major food source for the Maori, a fish hook was naturally an important symbol. Fish-hook carvings (*hei matau*) made out of bone or greenstone were carried or worn as good-luck charms. Furthermore, in Maori legend the North Island of New Zealand was "fished up" out of the sea by the great god Maui, using just a bone fish hook and a woven line. With legends such as these, it is easy to see why this simple symbol is so potent for the Maori and is featured so prominently in their body art as well.

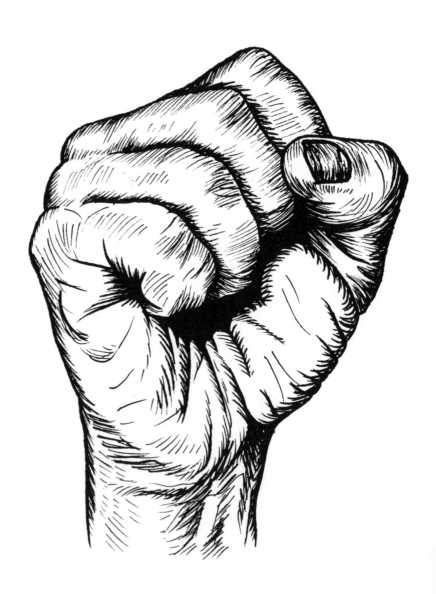

Fist

SEE ALSO
Justice *p117*

A universal symbol for strength and solidarity, the raised fist has been used by many different subcultures as a sign of resistance and power. The image is thought to date back to ancient Assyria, where it was used as a salute in the face of a violent enemy. Over the years it has been used by many different factions, from citizens in Mexico fighting social injustice, to resistance fighters in the Spanish Civil War (1936–9). Probably the best-known raised fist was the one adopted by the Black Panther Party as a means to show support for Black nationalism and solidarity among the African-Americans – as most famously by the athletes Tommie Smith and John Carlos at the Mexico Summer Olympics in 1968. The author Hunter S Thompson (1937–2005), founder of the gonzo journalism movement, used the raised fist as his logo when running for sheriff of Apsen, Colorado, adapting the standard design into a double-thumbed fist clutching a peyote button. Though he failed to win, the design will be forever associated with Thompson and gonzo journalism.

Five-yen coin

SEE ALSO
Fu dog *p93*
Maneki-neko *p133*

In Japan, the five-yen coin is considered a good-luck token and is often given as a donation at Shinto temples as this is considered to bring good karma. Another tradition is that the first coin placed in a wallet should always be the five-yen, as it is deemed to bring good fortune. The coin is often kept permanently in a purse or pocket, or a ribbon is threaded through the hole in the centre of the coin and worn around the wrist or neck. The reason that the coin is viewed as a good-luck token is down to how its Japanese name is

pronounced. The Japanese for "five yen" is *go en*, which also translates as "a respectful connection or relationship". Because of this, five-yen coins are also given as tokens of friendship.

SEE ALSO
Crescent moon and star *p56*
Quincunx *p175*
Star of David *p205*

Flag

Throughout history flags have been used as a marker of a group of people who share a common goal or common interests. The power that they now hold over the human mind can lead people to war or bring them to their feet or down on their knees. These pieces of coloured cloth, decorated with a symbol or image, can evoke fear, strength, power, pride, honour, or threat. Flags have been used to identify royalty, warriors, tribes, and clans, or to show allegiance to a religion or culture. In modern tattooing, flags feature predominantly as symbols of patriotism and pride. Flags have the ability to sum up a person's history, heritage, and beliefs in one simple but powerful image, instantly informing the viewer about who they are and where they come from, their past, and their present.

SEE ALSO
Jerusalem cross *p114*
Lion *p129*

Fleur-de-lis

Though it is now most commonly associated with the former French monarchy, the stylized lily, known as the fleur-de-lis, appears widely on European coats of arms. According to a French historian, the three petals are said to represent the social classes of medieval France – those who work, those who fight, and those who pray. Because of its aesthetically pleasing design, today the fleur-de-lis can be seen all over the world, across all artistic media, from architecture to fabric design, and sometimes as part of a background fill to larger ornate

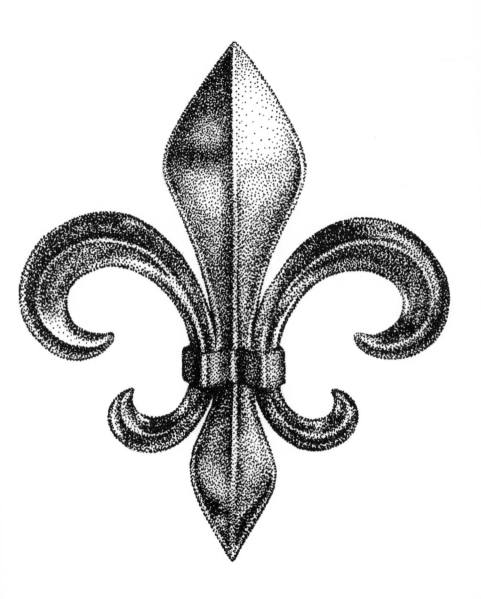

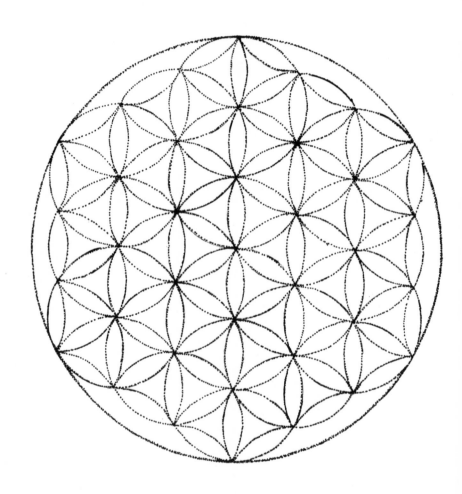

motifs. Though the fleur-de-lis has no one single symbolic meaning, its associations with royalty seems to enhance its popularity, a way of incorporating heraldry into everyday life.

Flower of Life

SEE ALSO
Fu dog *p93*
Mandala *p133*
Tree of Life *p225*

The motif of the Flower of Life – a geometric shape created by multiple overlapping circles of the same size – can be found in religions the world over. The design is said to contain the patterns of creation, and everything that exists in the universe can be related to the Flower of Life in some shape or form. The oldest known depiction of the Flower of Life is on the walls of the Temple of Osiris in Abydos, Egypt. In China, guardian lions (*shi* in Chinese or "fu dogs" in the West) are often depicted with something that closely resembles the Flower of Life beneath one of their paws, as though guarding the powerful knowledge it contains. Within the Flower of Life is found the Kabbalah Tree of Life, another sacred geometric motif. When projected into three-dimensional space, the Flower of Life also contains the Metatron's Cube, a geometric shape that holds all the Platonic solids, not just the building blocks of life but the building blocks of the universe itself. Even if we are dismissive of the arcane meanings reputedly contained in the Flower of Life, we cannot but help respond to its pure geometric beauty.

Flying eyeball

SEE ALSO
Eyeball tattoo *p77*
Kustom Kulture *p124*
Wings *p238*

One of the most iconic symbols of Kustom Kulture – the scene associated with custom-built cars and motorcycles in the United States that began in the 1950s – the flying eyeball was a design created by Von Dutch (Kenny Howard,

1929–92), the man considered to be the father of modern pinstriping (the decoration of custom-built cars, etc. using thin, free-hand lines). As Kustom Kulture enthusiasts typically also love tattoos and tattooing, Von Dutch's flying eyeball logo became a popular design for people to show their affiliation to this counterculture. Von Dutch states that the idea for the flying eyeball was influenced by ancient Macedonian and Egyptian symbols, which he redesigned as the famous logo we know today. Since Von Dutch first created the flying eyeball logo, it has been reinterpreted and reworked into a multitude of different designs and its popularity is as strong now as it was 50 years ago.

SEE ALSO
Jackalope *p113*
Mermaid *p145*
Octopus *p155*
Wolf *p238*

Fox

In most traditional cultures the fox has appeared as a trickster in possession of almost magical powers and as a symbol of cunning and guile. The archetypal portrayal of the cunning fox is to be found in Aesop's Fables. In Chinese, Japanese, and Korean folklore, the fox often takes the form of a beautiful, seductive woman in order to entrap men. Unfortunately, because of their curiosity, intelligence, and lack of fear, these beautiful animals have, more often than not, also acquired a negative symbolism – in the Middle Ages they were seen as creatures of the devil and were even burned at the stake. Today we are perhaps more likely to admire these creatures for the positive aspects of these same traits.

SEE ALSO
Maneki-neko *p133*

Frog

Frogs have a strong presence in folklore and fairy tales, where they are often viewed as symbols of transformation, as notably found in the tale of

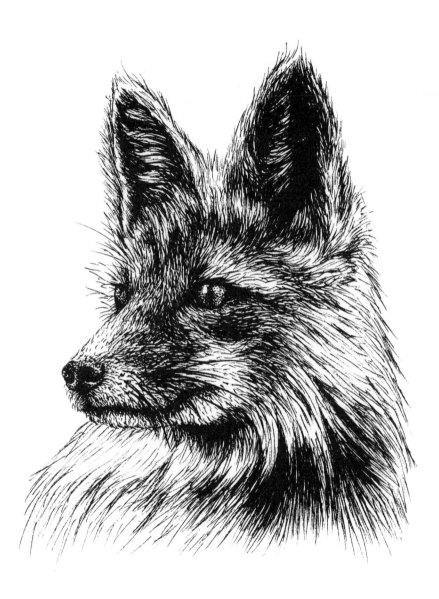

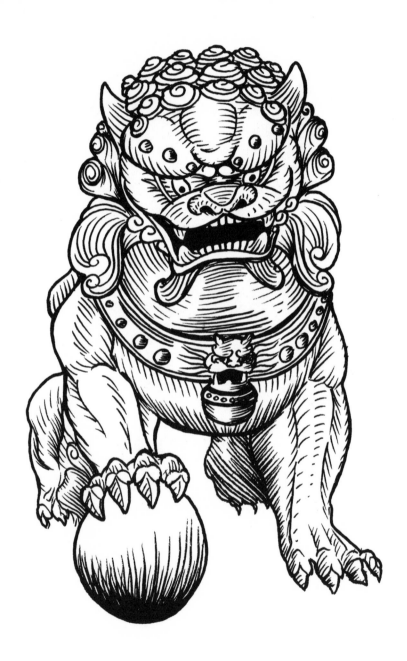

"The Frog Prince" as recorded by the Brothers Grimm. There, the frog regains human form by being thrown against a wall by the disgusted princess rather than being kissed by her as in most modern versions. The symbolism of frogs is often complex and ambivalent. In ancient Egypt they were symbols of fertility and life, as they appeared in their thousands every year after the inundation of the Nile, while in medieval times they were considered to be the familiars of witches. In modern-day China you will often see a frog placed near a place of business, or home, with a coin in its mouth, because, according to Chinese tradition, frogs are bringers of good luck and prosperity.

Fu dog

Temples all over Asia are guarded by sculptures known in the West as "fu dogs". However, these creatures are not dogs at all, but lions – Lions of Buddha, to be precise. Standing strong and proud in front of holy buildings, the male fu dog is usually portrayed as fierce, its mouth wide open to let evil spirits out. It is also often depicted with a sphere at its feet, symbolizing its role as protector of Heaven. On the other side of the entrance, or on its right, is the female fu dog. Not so fearsome in appearance, it has its mouth closed to keep evil spirits out. The female's feet are usually resting on a young cub, symbolic of its role as protector of the Earth. Because of these qualities of strength, protection, and courage, fu dogs are popular motifs not only in Japanese tattoo culture but also in Western tattooing.

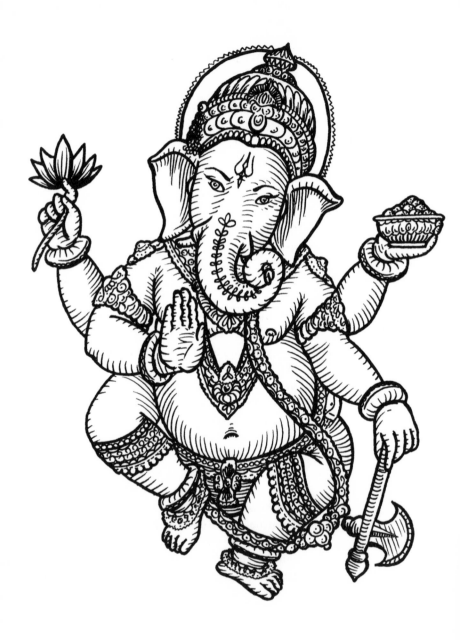

Ganesha

One of the most popular and revered deities in Hindu religion and culture, the elephant god Ganesha is the patron of the arts and sciences as well as being considered the remover of obstacles. Most commonly depicted as a man with an elephant's head, a big belly, and four arms, Ganesha also often carries a number of articles. In his upper right hand he may hold a goad (a sharp-pointed instrument), which he uses to push humans forward along their eternal path as well as to remove obstacles that hinder their journey. In his upper left hand, a noose, is used to pull his followers along their spiritual path. A broken tusk in his lower right hand is symbolic of sacrifice, Ganesha having broken his own tusk to write the ancient Sanskrit epic the *Mahabharata*, while an axe in his lower left hand is a means to remove all wrongful attachments. Ganesha's head symbolizes wisdom, while his trunk is identified with the Buddhist mantra Om or Aum, the primal sound, the sound of the universe. His elephant's ears urge us to listen to everything carefully; his small sharp eyes urge us to concentrate and pay attention to detail. Usually, Ganesha is depicted with bowls of food at his feet, a sign that the entire world is at our feet if we want it, as well as a mouse – a reminder that, though desires are good, we must master them.

SEE ALSO
Mother Nature *p151*

Green Man

Usually depicted as a face surrounded by, or composed of, wild foliage such as leaves, branches, and vines, the Green Man symbolizes nature and rebirth. At first sight, the Green Man seems to be an entirely pagan figure, associated with the worship of nature and fertility, yet he is one of the few pagan gods or spirits to appear on churches and abbeys. The earlier, pagan Green Man was often portrayed with a slightly malevolent visage, almost as a warning that we should follow the laws of nature, whereas in later Christian depictions he mellows out a little and seems more friendly and peaceful. This second aspect of the Green Man has seen a revival in modern times, mainly as a symbol of non-religious spirituality and of an eco-positive lifestyle.

SEE ALSO
Father Time *p78*

Grim Reaper

A skeletal, hooded figure carrying a huge scythe, the Grim Reaper has come to represent death throughout the world. Though he is supposed to be death itself, watching over us and ultimately coming to us when we breathe our last, in some cultures his work is rather to guide us from this earthly plane to the next. For the ancient Greeks he was seen merely as the opposite of life, much as in the tarot, where the Death card is seen not as an omen of actual death but as a sign of an end, of a great change or transformation. Most cultures have a personification of death in some form, though the shape it takes and his actual duties vary widely. In some cultures, for example in Latin America, death is actually conceived of as a saint and is portrayed as a woman.

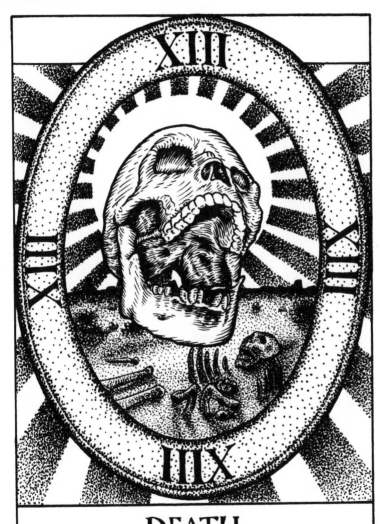

DEATH

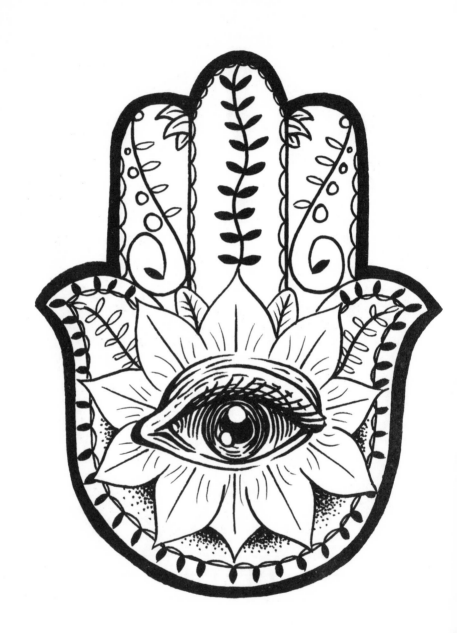

H

SEE ALSO
Eye *p74*

Hamsa

An old and still-popular design throughout the Middle East and North Africa, the hamsa hand is a palm-shaped charm or amulet that is used as a form of defence against the evil eye. (Indeed, in many cultures around the world, an open right hand is seen as a sign of protection.) Found as a motif in jewellery and on wall hangings, the hamsa is often decorated with mesmerizing patterns and other intricate details. Because this talisman is thought to protect against the evil eye, the hamsa hand is itself often shown with an eye in the centre of the palm. It is also believed that if the fingers are spread this will ward off evil, whereas if the fingers are closed good luck will come. The word "hamsa" derives from the Arabic word for five, *khamsa*.

SEE ALSO
Clown *p52*
Hot Stuff *p105*
Mask *p140*

Harlequin

Few comedic characters have a history as rich as that of Harlequin, who first surfaced in French passion plays of the eleventh century. Something of this mischievous, and sometimes malevolent, persona has lasted right up to modern times, where we find an echo of him, for example, in one of Batman's arch-enemies, the Joker. It was in the sixteenth century, once again in France, that Harlequin truly emerged as a stock character in

comedy. Often portrayed as a servant of a rich master, Harlequin was the agile, intelligent masked prankster who often inadvertently thwarted his master's plans. He is also seen as a bit of a womanizer, Colombina being his favourite target, though often any beautiful lady would do. An agent of chaos, this garishly dressed character quickly became a symbol of individual freedom and was probably one of the first true anti-heroes.

Heart

See "Sacred Heart".

Hells Angels

Besides the infamous death's head, or winged skull, that is seen on so many jackets and bikes of people belonging to the Hells Angels Motorcycle Club (HAMC), there are a few other symbols and designs that are linked to the organization. The number 81 is one of the most common ways of identifying a Hells Angel, using a simple alphabet–number code where the 8 stands for H and the 1 represents A. Red lettering on a white background is also used by Hells Angels, referring to the HAMC colours and nickname the "Red & White". More broadly, some motorcycle clubs wear a "one-per-cent patch", which is reputed to be a reference to a comment made by the American Motorcyclist Association to the effect that 99 per cent of motorcyclists were law-abiding citizens. Most motorcycle clubs, including the Hells Angels, now hold copyrights on their names and logos.

Henna

See "Mehndi".

H
100

SEE ALSO
Winged skull *p237*

"Hold Fast"

To old-school sailors who lived a life aboard ship, often in rough seas, the term "Hold Fast" was an expression of life or death. When climbing about the rigging in the middle of a storm, while the ship is being tossed around on the waves, being able to keep a strong grip on the ropes could make the difference between living to see the next day or ending up at the bottom of the ocean. In addition, to sailing folk, a rigging line that is tied up tight and secure is termed "fast". Other authorities, though, have the phrase originating from the Dutch *houd vast*, meaning much the same thing. Nowadays, in tattooing, the words are usually incorporated within a larger design, or tattooed across the knuckles – a reminder that, no matter how rough life gets, one must always be strong to see it through.

H

101

Holy Grail

Simple object though it is, the cup has been a ubiquitous symbol throughout history, rich in interpretations and metaphoric imagery, though the underlying emphasis is often that it represents our soul and its destiny. The most widely known cup must surely be the Holy Grail. There are endless theories as to what the Grail was or is, what it symbolizes and even where it lies hidden today. Said to be the cup Jesus drank out of at the Last Supper, or else the cup that the Roman soldier caught Jesus' blood in when he was on the cross, the Holy Grail and the quest to find it have long captured the imagination. The Knights of the Round Table endlessly quested after the Holy Grail, as a religious relic to retrieve and protect, while others sought after it as they believed that, when they drank from it,

it would give them eternal life. As a symbol of the soul, and our quest for enlightenment, the cup and the Holy Grail are examples of how a simple motif can capture our imagination and curiosity.

SEE ALSO
Octopus *p155*
Ribbon *p180*

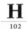
"Homeward Bound"

There is probably no other tattoo as iconic for a sailor as that of a fully rigged ship sailing the Seven Seas, usually worn as a full back or chest piece. Often, the design would include a banner coiled around the top or bottom of the ship, with "Homeward Bound" written across it. As well as being a proud visual emblem of the wearer's profession, it was also considered a good-luck image, the words urging the sailor to return to his home port, safe and sound, after a long journey at sea. In other sailor folklore, a fully rigged ship tattoo was earned only once the sailor had rounded Cape Horn, at the southern tip of South America, as this was considered one of the most dangerous routes to sail.

SEE ALSO
Cat *p44*
Compass *p55*
Die/dice *p64*
Eight-ball *p73*
Fish hook *p83*
Hamsa *p99*
Lucky 13 *p132*
Rabbit foot *p177*
Shamrock *p197*

Horseshoe

The horseshoe has long been associated with good luck, and in many cultures it is hung on doors or in doorways, to bring luck to those who live within the house. There are many variations on this piece of folklore, with some believing that it was necessary to hang the horseshoe with the points facing upwards, so that it acted as a container for the good luck. Conversely, hanging it upside down, some believed, would bring misfortune, as the luck would flow out of the horseshoe. In the past, horseshoes were considered lucky because they were made by blacksmiths, whose profession was considered to have "special" or even magical powers.

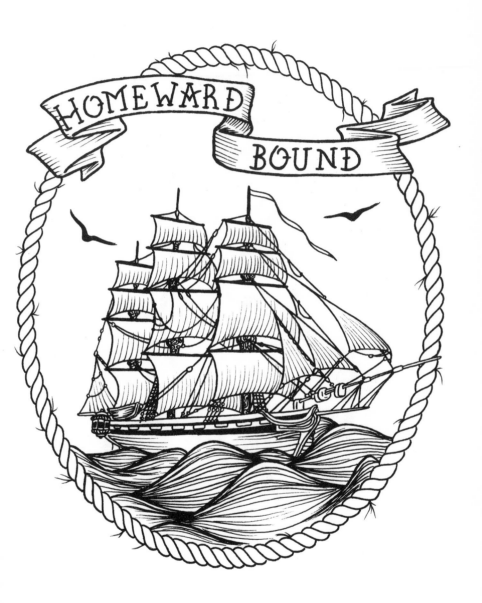

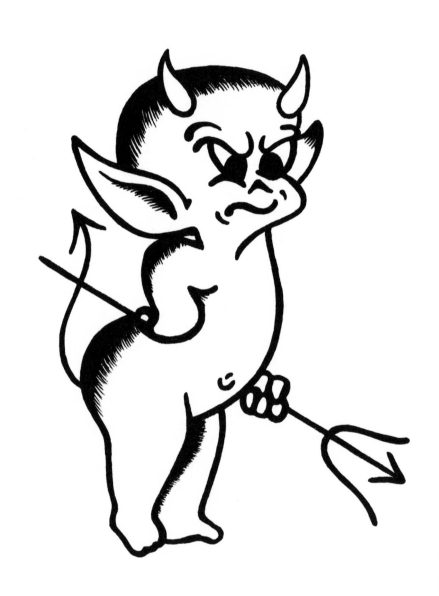

Horseshoes also used to be made from iron, which was considered magical as it could withstand fire and was much stronger than other metals.

Hot Stuff

Hot Stuff, the little red devil often depicted brandishing a trident, has been a mainstay in the tattoo world since 1957, when he first appeared in the eponymous comic-book series created by Warren Kremer (1921–2003). Comic-book characters have always translated smoothly into the world of tattoos and Hot Stuff is no different. His cheeky grin, mischievous demeanour, and the various personae and professions he could be linked to – biker, sailor, soldier – made him a popular choice in the early days of tattooing. At one stage he was so popular that entire flash sheets were dedicated to his image. These days, Hot Stuff, the Little Devil, is seen more as a nostalgic tattoo and it is rare to find a tattoo featuring him, but his image is still popular elsewhere and the comics and collectables that feature him are considered prize finds to some.

Hourglass

See "Father Time".

H

105

Icarus

The Greek mythological story of Icarus, the boy who flew too close to the sun, is a powerful and popular design in art, the symbolism behind the story being interpreted differently depending on the context Icarus is used in. As a doughty hero who escapes his prison on Crete using wings of his father's design, Icarus is seen as a symbol of strength over adversity and reaching for one's dreams, of power, cunning, and bravery. At other times, he is portrayed as the fallen, flawed hero, who plummets to the earth because his pride and greed impel him to fly too close to the sun, whereupon the wax holding the feathers to his body melt, sealing his doom.

Ichthys

A symbol consisting of two intersecting arcs, the ends of the right side extending outwards, so as to resemble a fish and its tail seen in profile, the ichthys is an ancient Christian symbol. In Greek, *ikhthýs* is an acrostic for "Jesus Christ, Son of God, Saviour". Nowadays known as the "sign of the fish", the ichthys started life as a secret symbol in early Christianity. Early Christians, often threatened with persecution under the Roman Empire, used the fish as a secret symbol to mark out friends as well as Christian tombs

and meeting places. Much later, in the 1970s, some modern Christians once again used the ichthys as a symbol of their faith and it soon got the nickname the "Jesus Fish".

Illustrative

SEE ALSO
Old school p155
Realism p179

A fairly new style, illustrative takes design elements from both realism and old school. Illustrative makes use of the black lines and bold colours of old school, while also incorporating realistic shading techniques, to create an image that looks like an illustration rather than a photo-realistic piece. Illustrative tattoos are usually quirky and humorous, often including relevant pop-cultural references hidden within the tattoos. Many artists working in the style of illustrative tattooing will make use of photographic reference material, but twist it to give a cartoony feel to the tattoo. The subject matter is also often tweaked so that the final design is slightly surreal, even if the overall atmosphere remains realistic; for example, inanimate objects and animals are anthropomorphized and often pictured doing things with which they are not normally associated. Many illustrative artists are inspired by animated film studios such as Disney Pixar.

Infinity symbol

SEE ALSO
Ouroboros p158

The figure 8 lying on its side is known as a lemniscate and is used as the mathematical symbol for infinity. Though it has long been used as a religious symbol in one form or another, it was the English mathematician John Wallis (1616–1703) who is credited with first using it as a mathematical symbol, in 1655. Interestingly, in geometry it relates to *potential* infinity, not

actual infinity. Since then, it has been adopted by mystics and spiritual folk as a sign of everlasting life, much like the ouroboros, the snake eating its own tail. In addition, because it can be seen not only as one continuous curving path but also as two separate circles joined in the middle, the infinity symbol has also come to represent opposite forces joined to create harmony – for example heaven and earth.

SEE ALSO
Yakuza *p243*

Irezumi

Depending on how it is written in Japanese, irezumi, the traditional art of Japanese tattooing, means either "to insert ink" or "decorating the body". The practice of tattooing in Japan, either for body decoration or for religious motives, is thought to date as far back as 10,000 BC. The role of tattoos has changed course many times since, sometimes used as a mark of affiliation, other times to mark out criminals. Up until 1948 tattooing was banned in Japan, as in more modern times they were mainly associated with the yakuza, Japan's version of the mafia. However, since then the art of tattooing in Japan has flourished. The Japanese view tattooing almost as a sacred art form, and people wishing to become tattooists are expected to serve as an apprentice under a master tattooist, a *horishi*, for a long period of time. Though many *horishi* working today started out tattooing by hand, with the advancement of technology, some have moved over to electric tattooing, or use a combination of both.

Jackalope

The existence of this so-called species of rabbit, with antelope-style horns, is an enduring urban myth, rumoured to be now extinct though still often "sighted". According to North American folklore, the jackalope is an aggressive critter that is willing to fight any enemy, earning it the nickname the "warrior rabbit". In the days of the Wild West, jackalopes were rumoured to have "sung back" to cowboys as they sat around their fires singing. Their uncanny ability to mimic the human voice would often be used by them to avoid capture if they were being pursued. Jackalope milk was highly sought after, as it was considered to be a love potion, though it was not deemed wise to try to milk a jackalope – the reason why having never been passed down with the warning. Both Sweden and Germany have similar antlered rabbits in their folklore, though it is not known what qualities or powers these European jackalopes possess.

Jack-o'-lantern

Originally used in English folklore as a term to describe the strange lights – also known as a will-o'-the-wisp – that sometimes flicker over peat bogs, jack-o'-lantern is now firmly associated with Halloween, used for the

carved-out pumpkins into which candles are placed. It is believed that the tradition of carving pumpkins for Halloween originated in Ireland and the Scottish Highlands. In the past, the Celts celebrated Samhain, rather than All Hallows' Eve, a time when the dead were said to walk the earth. Jack-o'-lanterns were thought to ward off evil or mischievous spirits, so placing them outside the house was a way of protecting people's homes. Pumpkins are typically carved with grotesque faces, as it was believed that the scarier the image, the more effective the jack-o'-lantern was at chasing away the evil spirits.

Jerusalem cross

In 1862 Albert Edward, Prince of Wales (the future Edward VII) was reputed to have had a Jerusalem cross – also known as a crusaders' cross or a five-fold cross – tattooed on his arm during a trip to the Holy Land. At this time tattooing was fashionable among the aristocracy and many a high-ranking member of society would have been tattooed. The design originates in a coat of arms used during the First Crusade (1096–9) and was used for the next two hundred years as the arms of the Christian King of Jerusalem. The symbolism of the five crosses is attributed to the five wounds of Christ. Though the Jerusalem cross was once used extensively in heraldry, it is now found only as the symbol for a few Christian churches and organizations as well as an unofficial symbol for Christian Deism.

Jesus

The image of Jesus Christ has figured prolifically in tattooing down the centuries. Along with the Virgin Mary, tattoos of Jesus have been

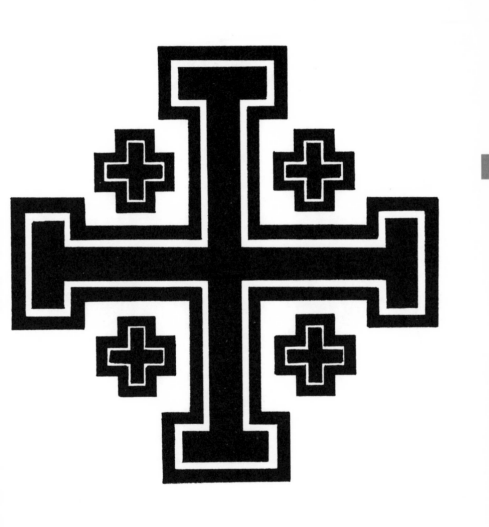

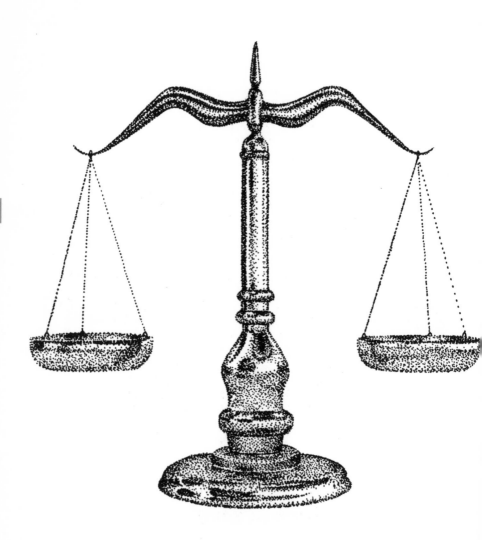

not only proudly worn as a symbol of religious faith, but also as a sign of hope, inspiration, and strength. However, aside from its obvious religious connotations, there is some interesting folklore relating to the reasons for getting a tattoo of Jesus. Christian sailors would often get a portrait of Jesus, or in some instances the Crucifixion, tattooed onto their backs in the hope that, should they face a lashing while at sea, the person administering the punishment would be more lenient when faced with the image of the Saviour. In the Russian prison system, a tattooed image of Jesus on the cross was intended to show that the wearer was a "Prince of Thieves".

Justice

SEE ALSO
Fist *p85*
Sword *p212*

Through different cultures the image of ideal, unbiased justice has taken many forms, the most simple being a set of scales, on which the merit of one's life is measured. In ancient Egypt, Maat was the goddess of truth, justice, law, and order. Her primary role was to weigh the souls of the dead and decide whether they should be allowed access to the afterlife and everlasting paradise. In ancient Greece, this role was taken by Themis, the goddess of justice, who was depicted carrying a set of scales and a double-edged sword. The image of Lady Justice that we most often see today is based on that of the Roman goddess Justitia. She, too, holds a set of scales in one hand and a sword in the other. The sword is often shown as being lower than the scales, a sign that evidence must be considered before punishment is dealt. The idea of Lady Justice wearing a blindfold appeared only in the fifteenth century as a sign that the evidence must be viewed on its own merit and without bias.

和

Kanji

Based on ancient Chinese characters, kanji are elaborate, ornate symbols that form part of the Japanese writing system, with each one used to express a whole word or stem of a verb or adjective (rather than a sound as in Western alphabets). As far as tattooing goes, the biggest danger with kanji is that often the tattoo is executed by an artist who has no first-hand knowledge of kanji or, indeed, of Japanese, so that what the wearer actually intends the kanji to represent and what the character actually stands for can be poles apart. Just as with English homographs, many kanji characters have multiple meanings. Another mistake people often make is to combine two kanji characters that express an altogether different meaning than might have been expected. It is because of this inherent ambiguity that the use of kanji has declined in popularity in the West in recent years. The best thing to do when thinking about getting a kanji tattoo is to go to Japan, or at least to go to an artist who is fluent in Japanese.

Kawaii

Though not really considered a style, kawaii (meaning "cute" in Japanese) is more of a design element, a name given to tattoos and designs that

are fun, playful, and often representative of the more cartoonish side of modern pop culture. Kawaii designs often feature recognizable and iconic characters, for example My Little Pony, Pokemon, and Hello Kitty, as well as quirky characters from movies such as those created by Japan's globally famous Studio Ghibli. The main attributes of the kawaii style is that the designs should be fun, colourful ... and, of course, cute. The appeal of kawaii is that nearly any subject matter or object – no matter how unlikely or serious – can be transformed using the style. For example, a kawaii tattooist might take a samurai warrior and morph it using the characteristics of My Little Pony.

Kewpie doll

At the beginning of the twentieth century Kewpie dolls were a common sight on tattoo flash walls, though by around 1950 they were viewed as old-fashioned. Looking at Kewpie dolls now, we might view them as odd, a strange choice for a tattoo design, but these dolls were considered part of the popular culture in their era and, as with most things in fashion, they found their way onto the tattoo scene. Kewpies started life in 1909 as comic-strip illustrations created by the American artist Rose O'Neill (1874–1944) and featured in quite a few adverts at the time. With their rise in popularity, they were soon made into first bisque and later plastic dolls. Kewpies were naked, chubby, angelic-looking dolls – indeed, the name is a shortened version of Cupid, the god of love, who was often depicted as a baby. Old-school artists translated the Kewpie into various different designs, and old flash sheets feature Kewpie dolls as mermaids, cowboys and even hula girls.

Key

Keys are a simple and easily recognizable symbol of our desire not only to protect that which is valuable to us but, on a more philosophical level, to unlock the secrets of life. We use keys in a practical way, to lock away our possessions and treasures, and to protect our homes and loved ones from the outside world, and we use them as a metaphor for our quest to access higher, esoteric knowledge. Often, in art as well as in tattooing, a lock is shown alongside a key – often as a metaphor for love and the key to one's heart. The Roman god Janus (from whom we get the name for the month of January) is often seen holding a key, symbolic of locking the door to the past year and opening the door to the future as the new year begins.

K

123

Khanda

Just as the cross is representative of Christianity, and the Star of David, Judaism, the khanda is the religious symbol of Sikhism. The emblem consists of four weapons and is a visual depiction of the Sikh doctrine of Deg Tegh Fateh ("Victory to Charity and to Arms"), which sums up the double duty of the Sikh community to provide food and protection to the oppressed. The emblem gets its name from the double-edged sword (*khanda*) that is at the centre of the design and which is a metaphor for divine knowledge. The circle surrounding the sword represents the chakra (a disk-like throwing weapon originating in India), symbolizing the perfection of God, who is eternal. The outer two swords (*kirpan*) remind Sikhs of the equal emphasis that must be placed on personal spiritual enlightenment and our obligations to society.

Knife

See "Dagger".

Koi

SEE ALSO
Dragon *p67*

A fish native to Central and East Asia, the koi carp can be seen in many traditional Japanese tattoos. Koi are associated with masculine characteristics such as strength and bravery, as well as being symbols of determination and the desire to succeed. According to legend, the koi in China would attempt to swim upstream, against the current of the Yellow River, and finally faced a waterfall known as the Dragon's Gate. Very few would even make it to that point and any that succeeded in climbing the waterfall would be rewarded by being turned into a golden dragon. For this reason, most koi tattoos will be placed on the body so that they are swimming "upstream" (that is, up the wearer's body). As with all Japanese tattoos, the secondary attributes of the motif are important: for this reason, colour and placement, for example, should be considered when choosing the koi as a design.

Kustom Kulture

SEE ALSO
Flying eyeball *p89*

Perhaps because they were both seen as underground cultures, to a certain extent outside and apart from the law, tattooing and Kustom Kulture have always had a close affinity. Born in 1950s southern California and closely associated with the hot rod movement of the 1960s, Kustom Kulture might have centred on the development and decoration of custom-built power cars and motorbikes but also extended to other areas such as fashion, hairstyles, and art. Tattoos related to Kustom Kulture

vary from famous logos and brands through images of custom-built cars and engine parts, including spark plugs and engine cylinders, to famous designs by associated artists such as Von Dutch (Kenny Howard, 1929–92) and Ed "Big Daddy" Roth (1932–2001).

SEE ALSO
Candle *p43*

Lantern

One of the classic old-school designs, the lantern is a simple motif that can easily be adapted for size and placement or incorporated into a bigger design. It is also a symbol that has varying amounts of symbolism attached to it and therefore can be used in many different contexts, according to one's own personal interpretation. Although technology had effectively made the lantern redundant and its use as an image is now shot through with nostalgia, as a symbol it still speaks to us. As the light that guides our way on stormy nights, the lantern is therefore the light that guides us on our life's journey, the light within us, or the enlightenment that comes with knowledge and understanding.

Lettering

See "Script".

SEE ALSO
Infinity symbol *p108*

Leviathan cross

Drawn as a double cross sitting on top of an infinity symbol, the Leviathan cross is most commonly viewed as a symbol for Satanism. Its original usage was as the symbol for the alchemical element sulphur, or brimstone, but it was adopted by Anton LaVey (1930–97), the

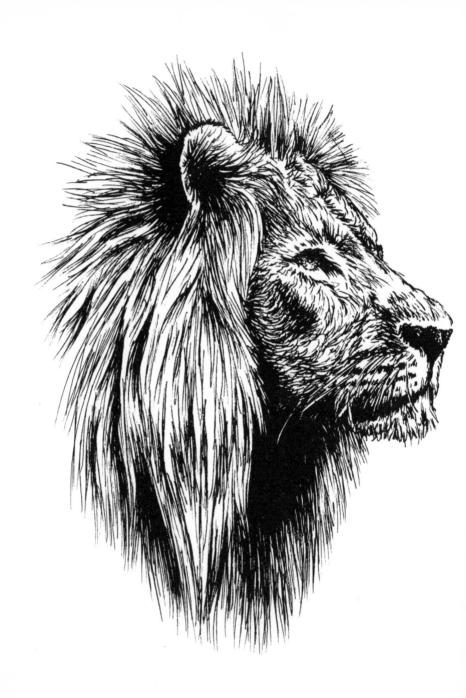

founder of the Church of Satan, as a sign of the
Devil. In alchemical thought, brimstone was
supposed to be the most masculine of all metals,
while mercury was the most feminine. There is
speculation as to why LaVey chose this symbol
to represent the Church of Satan, but no doubt
the links between hell and brimstone, fire
and sulphur, had a lot to do with it. The double
cross is thought to represent the equal balance
between woman and man, while the infinity sign
symbolizes eternal life and happiness.

Lily

The ancient Greeks associated the lily – said to
have been created from the breast milk of Hera,
the wife of Zeus and queen of the gods – with
birth and motherhood. In alchemy, the lily is
associated with the moon and feminine qualities.
For Christians, the lily is a symbol of chastity, and
often the Virgin Mary is depicted holding one,
especially in scenes depicting the Annunciation.
The three petals of the lily are said to represent
three "theological virtues" – faith, hope, and
charity. Like the pure-white dove, wherever you
see the lily, whatever the mythology or culture, it
is a symbol used in the context of the pure of soul.

L
129

Lion

The king of the beasts, the lion has always been a
popular motif in folklore, art, and tattoo design.
Whether rendered realistically or stylized, the
lion represents strength, courage, fearlessness,
and wisdom. Many cultures feature lions in their
texts, both sacred and secular, and carvings and
paintings of them can be seen all over the world.
Lions feature heavily in the heraldry of royalty,
once again linking the lion to its place at the apex

of the power hierarchy. Lions are also associated with inner strength – symbolizing how we can reign over our emotions and actions.

Lotus flower

SEE ALSO
Buddha *p37*
Dharma wheel *p63*
Endless knot *p74*
Tree of Life *p225*

Not only is the lotus flower admired for its beauty, but, especially among Eastern cultures, is also laden with significance. In Hindu culture, the lotus is associated with divine beauty and purity, its unfurled leaves suggesting a spiritual awakening or expansion of the soul through meditation and insight. In Buddhism, the lotus symbolizes purity of the body, mind, and spirit, floating on the muddy waters of attachment and desire. The Buddhist lotus flower is depicted with eight petals (whereas in Hinduism it usually has many more), symbolizing the Noble Eightfold Path, a core principle of the Buddha's teachings. The colour of the lotus flower is important, too, as different colours represent different qualities or states of being. A red lotus, for instance, is related to love and compassion. In addition, the form of the lotus, whether open, closed, or partially closed, also has different meanings relating to one's spiritual state.

Love dots

SEE ALSO
Blackwork *p36*
Claddagh *p52*
Dot-work *p66*
Rose *p183*

Probably the smallest tattoo you will ever find, the love dot originates in Japanese culture during the Edo period (1603–1868). It is said that lovers, especially those who could not publicly show their affection, would have a small dot tattooed between the base of the thumb and the wrist, so that when they held, or clasped, hands in public the tips of their thumbs would be next to the dot on their lover's hand. Around this era there were no professional tattooists, so often

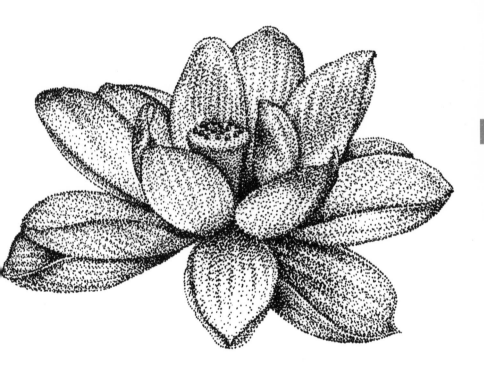

the dot was applied by the lovers themselves or by a sympathetic friend of the lovers. There is some evidence that love dots were sometimes worn by emperors and courtesans, as well as by homosexual men who were unable to reveal their love publicly.

SEE ALSO
Eight-ball *p73*

Lucky 13

Considered an unlucky number by most people, for tattooists the number 13 has always been a symbol of good luck. Though the origins of this belief go back to the old traditional days of tattooing, the motivation behind it has long since been lost. One explanation states that the reason for getting this tattoo was because, if bad luck came your way and saw the number 13 tattooed on you, it would assume that you had already had enough misfortune and would pass you by. Others believe that having unlucky symbols as tattoos reverses their meaning. Whatever the reason, the myth has stuck and getting a lucky 13 tattoo on Friday 13th is still a tradition that many tattoo artists follow, some even offering the tattoo at a "lucky" price, itself involving the number 13.

L

Machine

See "Biomechanical".

SEE ALSO
Sanskrit *p192*

Mandala

Its name originating from the Sanskrit word for "circle", the mandala is, in Indian religions, a spiritual and ritual symbol of the universe. The basic design of a mandala originally comprised a square with four T-shaped "gates" and, inside the square, a circle containing a centre point, although today this core idea is open to a wide range of variations and personal touches. Most mandala designs seek to achieve a geometric, or radial, balance, both across the entire form as well an in the intricate patterns used to decorate them. In modern times, the term "mandala" has come to be used to describe any diagram, chart, or pattern that serves as a visual metaphor for the universe or cosmos. In many religions, a mandala is used as a meditation aid, as a way of focusing the mind. Many see the mandala as not only a reflection of the universe, but also as a symbol of the self and its place in the order of things.

SEE ALSO
Frog *p90*
Fu dog *p93*

Maneki-neko

In traditional Japanese folklore, a cat washing its face meant that a visitor would soon arrive or

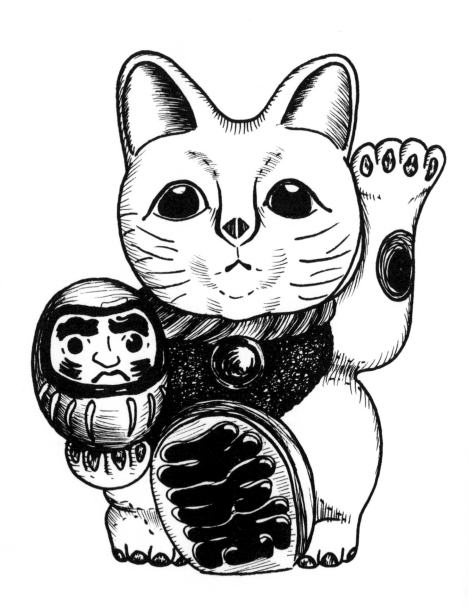

else that it would soon rain, which in turn would entice a visitor through the door, out of the wet weather. This belief gave rise to the popular figurine known as a maneki-neko – depicting a white cat waving its paw – often worn as a good-luck charm or, in larger form and made out of ceramic or plastic, displayed outside a shop. Though many Westerners believe that a maneki-neko is merely waving at them, it is actually beckoning them inside, as the translation of the name suggests ("beckoning cat"), no doubt to spend their hard-earned cash. A maneki-neko is most often shown as white, but different-coloured cats attract different things – white summons good luck, while gold brings money – and what the cat wears around its neck will depend on what the owner would like most in their life. Often, the cat is depicted holding a coin, another symbol for good fortune and monetary wealth. The higher the beckoning paw is held, the more prosperity the cat attracts, which has resulted in some maneki-neko having very long arms!

M
135

Manga

Manga is the name given to comics first created in Japan in the late nineteenth century and are today a very popular art form around the world. Because of their stylistic simplicity, manga are easily transferable to the medium of tattooing. In Japan, manga are read by everyone, from all walks of life, and cover a mind-blowing variety of subjects, from pure fantasy to heavy social and philosophical ideas. Manga tend to have very adult themes and are not what, in the West, would be considered "comics". Though manga have a long cultural history in Japan, the modern style of manga dates from around the end of the Second World War.

Man's Ruin

One of the most iconic images within the old-school lexicon of tattoos, Man's Ruin – and variations on it – can be found on old flash sheets as well in the portfolios of modern artists. The central motif of Man's Ruin is usually a sexy, seductive pin-up girl, who is surrounded by all the vices that can ultimately lead to a "man's ruin". Commonplace, along with the often scantily clad woman, are drinking glasses, bottles of alcohol, and all the usual signs and symbols of gambling – dice, cards, eight-balls, and horseshoes. In the tattoo parlours of the past, the Man's Ruin image could often be found displayed alongside an almost identical design entitled Man's Vices, which leads one to believe that the tattoo was probably more tongue-in-cheek than serious, representative more often that not of men's pleasures rather than their ruin. Imaginative new-school artists have reinterpreted Man's Ruin over the years, keeping this old-school design current with changing times, and adding new vices such as modern technology.

Maori patterns

Much of Maori tattooing is made up of repeating patterns and symbols, often used as background decoration or fillers. Superficially, these patterns seem to be merely geometric designs, but most have a very specific association and meaning. Single lines with triangles pointing outwards from them (*taratarekae*) are representative of teeth – if the triangles are large, they are shark's teeth; if they are small, they are whale's teeth. A fish-scale pattern (*unaunahi*) symbolizes abundance and health,

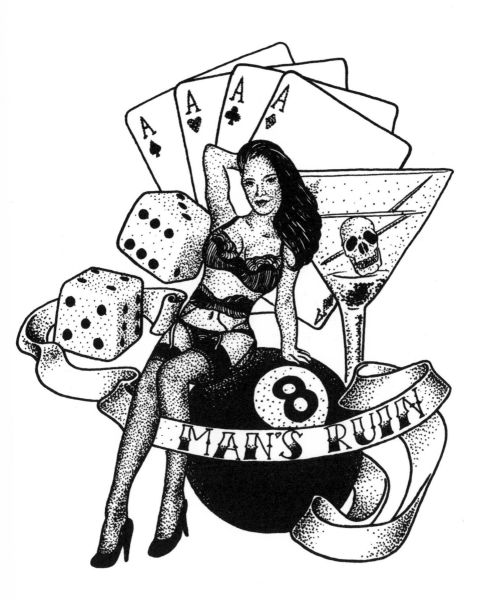

while dog-tooth notches (*pakati*) represent strength and courage, tattooed onto Maori who have proved themselves warriors in battle. Such decorations were also traditionally carved or incised into other Maori objects, from food bowls to weapons.

Marquesan

Easily identifiable by their commonly used symbols – such as geckos, turtles, and the so-called "Marquesan cross" – as well as by their use of simple patterns of arches and circles and heavy black-line rendering, Marquesan tattoos originated in the Marquesas Islands of the South Pacific (now part of French Polynesia). Though tattooing was not confined to the elite of the peoples on these islands, it was only the chiefs and higher-ranking officials who could afford to employ a tattoo artist, so much of the photographic and written evidence about Marquesan tattooing is focused on these males and their work. A German ethnologist who visited the islands in 1890 recorded no fewer than 170 named tattoo motifs – a number all the more astonishing when you consider that tattooing had been banned on the islands by French colonial officials for the previous 50 years. Boys received their first tattoos (as part of a coming-of-age ritual) in their early teens and thereafter received many more over their lives. Women, it seems, were not so heavily tattooed. It is thought that the tattooing culture of the Marquesas Islands contributed in part to the rise in resurgence of tattooing among Western sailors, after the British Royal Navy captain and explorer James Cook (1728–79) visited the islands in the early 1770s.

M

Mask

Masks have been used by most cultures throughout history, not only as a means to convey a story within a storytelling medium such as drama, but also during tribal rituals and war. Masks can be used both to reveal a hidden or inner identity, as well as to conceal it; therefore they are symbolic not only of how we face the world, but also of the truth that lies beneath. The motif of the two masks – one laughing, one sad and crying – originally associated with drama and theatre, is still popular today as a symbol of the duality of life. Its use can be traced back to ancient Greece where it represented the traditional division between the two 'schools' of theatre – comedy and tragedy, whose patron-goddesses were the two muses Thalia and Melpomene, respectively.

Matryoshka doll

Also known as the Russian nesting doll, the matryoshka doll is a set of typically seven wooden dolls that decrease in size, each doll splitting in mid-section to reveal another doll within. Usually, the dolls are painted to resemble a pretty young Russian peasant woman dressed in traditional clothing. The dolls became popular in about 1900, though the concept is based on a far older idea originating in China. *Matryoshka* translated from Russian means "little matron", so both name and form suggest motherhood and fertility, as well as the idea of matrilinear descent (tracing one's ancestry down the female line). Over time, an abundance of different designs have appeared, depicting everything from Russian political leaders to animals.

Medusa

According to Greek mythology, Medusa was
originally a ravishingly beautiful woman who,
as a punishment for some crime, was turned into
a monster with a head of snakes as hair. Exactly
why she suffered such a fate was variously told:
according to one version, she was raped by the
sea god Poseidon in the temple of Athena, while
in another, she enraged the goddess by boasting
that she was more beautiful than her. Either
way, Athena turned her into the snake-haired
monster and cursed her so that anybody who
looked at her was turned to stone. In one telling
of the story, she subsequently wandered the
earth in despair, finally ending up in Africa.
The young serpents that would "hatch" from
her hair would drop to the ground and that is
reputedly why there are so many venomous
snakes in Africa. After her death at the hands of
the hero Perseus, the goddess Athena was said
to have fixed Medusa's head to the middle of
her shield to strike terror into the hearts of her
enemies. There is certainly evidence that, among
the ancient Greeks, the image was considered to
have apotropaic powers – that is, it warded off
evil. As a tattoo, the Medusa motif is today chiefly
popular among fans of horror.

Mehndi

A mehndi is a temporary form of tattooing
carried out using henna, a paste made out of the
crushed leaves and twigs of the henna plant. An
ancient method of marking the skin, it is now
predominantly associated with India, worn
by brides and sometimes grooms at weddings.
Henna is applied to the skin in much the same
way as one would use a marker pen. Once on the

skin, the paste dries to form a hard crust; this is then left on the skin for a few hours before being washed off, leaving an orange-brown pigment that lasts for a week or two. Mehndi tattoos are made up from very intricate lines, forming complex, swirling patterns that can cover a small area or even the whole body. Most often seen on hands, mehndi is a very popular way of marking the skin, especially as designs fade with time.

SEE ALSO
Man's Ruin *p136*
Rock of ages *p180*

Mermaid

As long as men have sailed the open sea, mermaids have existed in our mythologies. Much Western folklore has sailors falling for a mermaid's siren song, which would haunt their dreams until they wrecked their ships on rocks as they sought out these sensual, darkly otherworldly beings. For this reason, mermaids are often depicted sitting on rocks, just out of reach, bare-breasted and combing their hair – a symbol of temptation and seduction. However, the image of the mermaid can have another, more positive meaning. Because of her association with water, many cultures have seen the mermaid as a goddess of fertility as well as teller of fortunes, able to reveal the future to a man lucky enough to win her favour.

SEE ALSO
Medusa *p142*

Minotaur

In Greek mythology, the Minotaur was a man with the head of a bull. He was the offspring of the queen of Crete, Pasiphaë, who was tricked into lying with a bull by the sea god Poseidon, who wanted to revenge himself on her husband, Minos, after he failed to sacrifice a white bull in his honour. After being born, the creature wreaked such destruction on Crete that he was

imprisoned inside a specially built labyrinth. Every year, seven men and seven women were sacrificed to the Minotaur in order to placate him. Only when the Athenian hero Theseus offered himself up as a victim in order to kill the Minotaur was this savage practice ended, the victor famously escaping the labyrinth by means of a ball of string. The myth of the Minotaur has survived unchanged over the years and has been recast in many stories as well as depicted in art.

SEE ALSO
A.C.A.B. *p13*

"Mi vida loca"

Spanish for "My crazy life", the tattooed motto "Mi vida loca" has long been used by Latinos as a symbol of pride in their heritage and has often been used by Latino gangs as a sign of their involvement in the gangster lifestyle. The motto, as well as the three dots in the shape of a triangle that can sometimes stand in for it, has subsequently spread out to non-Latino gang members. Moreover, as the symbolism of the motto and three dots has become better known in the mainstream community, it has been quite often adopted by people not even involved in gang culture, who wear the symbols merely as a rebellious act or as a statement of sympathy with the gangster lifestyle, without, of course, having to immerse themselves fully in it.

SEE ALSO
Crow *p56*
Fox *p90*
Rabbit foot *p177*
Wolf *p238*

Monkey

Monkeys feature prominently across different cultures and in their mythologies and, because of their mischievousness and sense of fun, soon crossed over into the world of tattooing. A cheeky old-school favourite is the Aloha Monkey. Created by the American tattoo artist Sailor Jerry (Norman Keith Collins, 1911–73) while he

was working out of Hawaii, this monkey is often seen on traditional flash sheets, bending over to reveal more about himself than he should. Another favourite is Hanuman, the Hindu god who takes the form of a monkey to fight alongside Rama. In most cultures, the monkey is seen as a "trickster", whose sole purpose in life is to wreak havoc amid the human population. In many Asian cultures, the monkey is considered a sacred animal who is allowed to roam the land unhindered by human beings.

Moon

The brightest and biggest celestial body in the night sky, the moon has played a central role in myth and legend – and in human consciousness – since the very dawn of humanity. Because it appears during the hours of darkness, the moon is closely associated with mystery, magic, and witchcraft. Unlike the sun, whose image remains static, the moon waxes and wanes, changing shape as time passes, and therefore reminds us of the cycle of life and how, even though things are constant, they are also ever-changing. In some cultures, the moon is feared but at the same time respected – a symbol of power and death – while in others, it is seen as a symbol of life, birth, and rebirth. In modern mythology, the moon is associated with madness and evil (we have only to think of the pop-cultural obsession with werewolves, who traditionally underwent their transformation with each full moon), although it is also linked closely with love and magic. Whatever we associate with the moon, it remains a powerful symbol, summoning up deep emotions from the human psyche.

Mother Nature

In Greek mythology, Mother Nature (Gaia) was the personification of the Earth, the great mother of all. Everything that was created in the universe was said to be born from her, including all the gods. She is seen as the embodiment of all nature and is often depicted in beautiful natural settings, surrounded by wild animals. Her usual demeanour is peaceful, loving, and tender but, when angered, she is associated with stormy weather and natural disasters. Through different cultures and religions, Mother Nature is seen as the perfect mother, the protector of children, the goddess of nature, music, and fertility. Though she was worshipped in most ancient religions, in more modern times she was replaced by other religious figures, for example the Virgin Mary. Today Mother Nature has made something of a comeback, held in high regard principally by New Age spiritualities as well as by pagan-based religions such as Wicca, especially in the context of the rise of environmentalism.

M

151

N

SEE ALSO
Compass *p55*

Nautical star

Stars have always been popular symbols in tattooing. However, for sailors, the North Star, or Polaris, has always had an especially potent significance, especially in the days when sailors did not have modern equipment such as GPS as they travelled the proverbial Seven Seas. Navigation, in the early years of sailing, relied heavily on an ability to read the night-time sky and one of the most significant of the celestial bodies was the North Star, or Polaris. Always a constant in the dark hours on the sea, the North Star was an essential guide, practically as well as spiritually, in the life of a sailor. For these early travellers, the nautical star became a symbol of good luck, safe travel, and safe passage home. In its symbolic form, the North Star became the so-called nautical star, used as an emblem by the sea services of the US Armed Forces as well as in tattoo culture.

SEE ALSO
Old school *p155*

Neo-traditional

Neo-traditional ("neo-trad"), or new school, is a modern-day reworking of traditional old-school flash. Rather than being about making straight copies of old tattoo flash designs, or even the stylization of modern imagery following the old-school "rules" of using bold black

lines, bright colour, and simple designs, new school adds a twist to the earlier tattoo style by adding newer artistic elements to the pieces. A lot of new school, for example, incorporates the geometric patterns, shading, and contrast usually associated with realism, while retaining the simplified and stylized forms of old school. Often, just as the artists of early tattooing did, new-school artists will plunder the icons and symbols of contemporary popular culture for their designs, whether characters from popular movies such as *Star Wars* or modern technologies such as mobile phones and game consoles, all the while rendering them in an old-school format.

SEE ALSO
"Homeward bound" *p102*
Ribbon *p180*

Octopus

With their multitude of dazzling colours and
patterns and their ever-changing and fluid form,
octopuses are animals that appeal purely on
aesthetic grounds, even if they can sometimes
also evoke feelings of unease, fear, or revulsion.
Artists have exploited this duality for centuries,
on the one hand making the octopus a symbol
of the unknown and, on the other, a symbol of
beauty and cunning. They have appeared in
many old-school traditional tattoos, often as part
of bigger designs such as "Homeward Bound".
Because of the flexibility and adaptability of the
octopus's body, the design can be moulded to any
part of the wearer, wrapping itself around limbs
or spreading across the back.

O
155

SEE ALSO
Neo-traditional *p152*

Old school

The motto of old-school, or traditional, tattooing
– "Bold will hold" – is the backbone of what this
style is all about – thick black lines, bold bright
colours, and simple, stylized designs. The
old-school style evolved out of necessity, since
technology was not as we have it today. Needles
were handmade and there wasn't a huge range
to choose from; colours were hand-mixed and
the variety of colours were limited (black, green,
red, and yellow were staples); stencils were

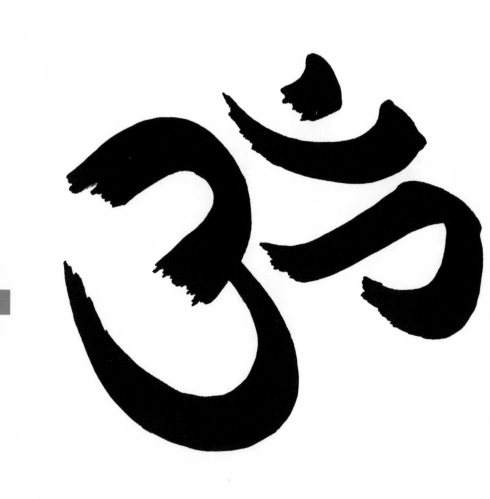

time-consuming to make and their designs were simple and reused often. Added to this was the fact that there were few artists around and their clientele was made up mostly of sailors and military people on leave, so they had to work fast. All of this contributed to the way in which old-school tattoos were designed and applied. Old school is still popular today, not only among new-generation tattoo artists but also with their clientele. For some, it is a question of nostalgia, a nod to the forefathers of modern tattooing, while for others, the pleasure is purely in the simple beauty of the traditional old-school designs.

Om

Just as Christian themes have become popular for tattoo designs, so too have symbols that are found within other religions. One of the most popular is Om, or Aum, a sacred utterance and spiritual icon in the Dharmic religions – Buddhism, Hinduism, and Jainism. Across these religions, Om is used to represent the universe, the first sound ever uttered, the beginning of everything, and everything that is. In Hindu scriptures such as the Vedas and the Upanishads, the syllable 'om' is often found at the beginning and end of chapters. In Buddhism, it forms part of a longer mantra, "Om Mani Padmi Hum", which, when written in Sanskrit, is also a popular choice as a tattoo. As spirituality increasingly transcends traditional concepts of religion, the crossover between different cultures almost forming a new global religion, these ancient sacred symbols are becoming more and more popular as a means for people to mark themselves out as spiritual, but not necessarily as religious.

O
157

SEE ALSO
Fu dog *p93*
Maneki-neko *p133*

Oni (demon)

One of the core principles of Japanese tattoos is that they should be big and frightening. They must be visible from a distance and have the ability to scare anyone who sees them. Therefore, oni, or horned demons or trolls, are one of the most popular Japanese tattoo designs. Generally, oni are fearsome, hellish creatures that are often depicted raging or in battle causing destruction. Though their facial features will change from artist to artist, oni are almost always shown with horns and often coloured pink, red, or bluish-grey. They are said to be creatures of the underworld, torturers who carry out the punishments meted out by the Queen of Hell. In older traditions, they are sometimes also seen as protectors: for example, monks were said to turn into oni after death in order to protect the temples in which they had served during their lifetime. Oni masks are also popular tattoos: often as whole back pieces depicting the creature's bulging eyes, snarling mouth, and large, pointed horns.

O

158

SEE ALSO
Bee *p29*
Infinity symbol *p108*

Ouroboros

A Greek word meaning "tail devourer", the ouroboros is an ancient symbol depicting a snake or dragon swallowing its own tail. The first known illustration of the motif is found in an ancient Egyptian funerary book, where it is used to symbolize both the sun god Ra and the god of the underworld Osiris. It is thought that, from this Egyptian source, the symbol slowly made its way into other cultures, where the meanings associated with it changed over time and according to geographical location. One of the most common interpretations attached to the

ouroboros is the idea of creation emerging out of destruction, and the endless cycle of death and renewal. The symbol was also closely associated with alchemy, where it was used to represent infinity and the eternal unity of all things.

SEE ALSO
Bat *p26*
Bird *p33*
Swan *p211*
Wings *p238*

Owl

Across cultures and down through history, people have regarded owls with a combination of curiosity, awe, and fear. In early folklore, the owl was associated with positive characteristics such as wisdom, helpfulness, and even the gift of prophecy, and in Greek mythology was the companion of Athena, goddess of wisdom. However, as time moved on, the owl began to take on darker connotations, associated with witches and dark lonely places, and feared as a creature of darkness. In the Middle Ages, people thought that if you saw an owl, death was near. In Cameroon, Central Africa, the owl does not even have a proper name, but is referred to superstitiously as "the bird that makes you afraid". Today, the owl continues to carry this ambivalent reputation, seen both as a creature of wisdom and of darkness.

O

P

Pachuco cross

A gang tattoo associated with Chicano (Mexican-American) gang members, and sometimes also known as the "la cruz del barrio" (cross of the neighbourhood), a pachuco cross is usually worn between the thumb and the forefinger of the left hand and consists of a cross with three lines radiating out from it. Tattoos like the pachuco cross are often used as part of the initiation ritual when a new member joins a gang, as well as serving, of course, to show solidarity and allegiance. Each line radiating from the cross is sometimes said to signify a six-month stretch in prison, but there is no hard evidence to support this. The word *pachuco* itself refers to a 1940s Mexican-American and Latino subculture whose members dressed smartly in zoot suits and were given to flamboyant public behaviour.

Panther/jaguar

The panther – solitary, graceful, nocturnal, powerful – is a powerful symbol in several mythologies. To Native peoples of North and South America, the black-coated jaguar (the only species of panther found on the continent) is a powerful totem, imbued with great magic and power. For the Tucano people of the north-west Amazon, the roar of the jaguar was the

roar of thunder, and eclipses were caused when the jaguar swallowed the sun. In Chinese mythology, the panther was seen as feminine, as a seductress, mother, and warrior. In medieval times, it was believed that the panther, after feasting, would sleep in a cave for three days, after which it would awaken and roar. Its roar released a sweet smell that would attract any creature that smelt it and the panther would feast again, after which it would return to its cave to repeat the cycle.

Peace sign

SEE ALSO
Arrow *p21*
Buddha *p37*
Candle *p43*
Dove *p66*
Swastika *p211*

In 1958 the British artist and designer Gerald Holtom (1914–85) created the peace sign as a symbol for the Campaign for Nuclear Disarmament (CND). There has been much speculation about how the symbol came about and what it initially stood for, though Holtom claimed that the sign was meant to represent a person standing with his or her arms outstretched at a downward angle, to show defeat or supplication. Another theory of the time was that it combined the semaphore signs for the letters N and D, representing "Nuclear Disarmament". Whatever its origin, this striking symbol quickly grew in popularity and during the 1960s it became the stock emblem of the peace and anti-Vietnam War movements. Some radical Christian groups view the peace sign as a Satanic symbol, claiming that it in fact depicts a cross with its horizontal bar broken.

P

165

Peacock

SEE ALSO
Bird *p33*
Butterfly *p40*

Unsurprisingly, the peacock, with its shimmering plumage and majestic gait, features prominently in cultures around the world.

According to the ancient Greeks, a peacock's flesh did not decay after it died, and they therefore considered it to be immortal. Early Christians picked up on this idea and adopted the peacock as a symbol of resurrection and eternal life, often carving or painting it onto tombs. The peacock also features heavily in Hindu culture, being the mount for Kartikeya, the god of war. It also adorns the crest of Krishna, the eighth avatar of Vishnu. In ancient Babylonia, the peacock was associated with royalty and can be seen on ancient royal thrones. Aside from its rich history in legend, the peacock's esoteric beauty has ensured that it is a popular motif not only in tattooing but in art more generally.

Pentagram/pentangle

A five-pointed star, drawn with five straight lines, the pentagram is a symbol that is nearly always associated with magic and the esoteric arts. There is evidence for the pentagram as far back as the ancient Babylonians, and in early Christianity it was symbolic of the five senses or else of the five wounds of Christ. In medieval romance, Sir Gawain, one of King Arthur's most famous knights, bore a pentagram on his shield as a sign of his virtue. The upward point was supposed to represent the self, with the other four points symbolizing the four elements. By the Renaissance times, the pentagram had been adopted by occultists as a magical symbol, but it was the French writer and magician Eliphas Levi (1810–75) who created the idea that the pentagram inverted was a sign of evil. This was later picked up by Anton LaVey (1930–97), who used the inverted pentagram encased in a double circle as a symbol of his newly formed Church of Satan.

P

166

Pharaoh's horses

SEE ALSO
Horseshoe *p102*

It is not certain where this image originated, or the true meaning behind it, but over the years Pharaoh's horses – said to be those that drew Pharaoh's chariot as he pursued the Israelites during their flight from Egypt – has become a popular design in the tattoo world. The oldest known depiction of the subject was in an 1848 painting by the Victorian artist and sign-painter John Frederick Herring, Sr (1795–1865), though the first time it appeared in the tattoo world was via a design by the American tattooist August "Gus" Wagner (1872–1941) around the turn of the twentieth century. A potent image of power, majesty, and grace, Pharaoh's horses is still a common design today, usually rendered as a chest or back piece, though most artists probably have little or no idea of its place in tattoo history.

Phoenix

SEE ALSO
Bird *p33*
Wings *p238*

P

The story of the phoenix is familiar to most: a mythological bird that, after a long life, bursts into flames, only to rise from the ashes stronger and more beautiful than ever. Because of this, the phoenix has long been associated with life, death, and rebirth. The earliest known representation of the phoenix is in ancient Egypt (in the form of the heron-like Bennu-bird) and it can be traced through most civilizations and in many religions, though sometimes with differing interpretations. In ancient Roman times it was stamped onto coins to symbolize the endurance of the empire, while in China the phoenix was seen as a symbol of marriage. Whether depicted as a beautiful bird in flames or rising renewed from its ashes, it remains a powerful symbol of endurance, triumph, and rebirth.

Pig and rooster

Not a very common tattoo these days, the pig and rooster were once a favourite among sailors in the early days of seafaring. According to tattoo history, this tattoo originated as a symbol of good luck because, if ships carrying a cargo of roosters or pigs (both of which were kept in lightweight wooden boxes) sunk, the boxes could serve as flotation devices for the sailors who were adrift at sea. Another story passed down about this tattoo was that it illustrated the nautical saying, "A pig on the knee, safety at sea. A cock on the right, never lose a fight". In this instance, the pig was shown resting on the sailor's left knee while the rooster was perched on the right.

SEE ALSO
Man's Ruin *p136*
Old school *p155*

Pin-up girl

As long as men get tattoos, pin-up girls will feature within the tattoo world. The history of the pin-up girl is as old as tattooing itself and the pin-up has always held a place in the heart of sailors and military men. What better way to remember the girl you left back at home or your favourite movie starlet (before modern photography, mobile phones, and social media, of course) than having her image tattooed on your body? Most of the earliest designs for pin-ups were based on the cinema beauties of the day and, in form, were usually simple and two-dimensional, though even so they managed to convey all the sexual allure of the women they portrayed. Nowadays, the pin-up girl is often seen on women, too, no doubt because as a motif it perfectly conveys the strength and beauty of the female form. The pin-up's iconic status as an old-school design must play some role here, too.

Playing cards

The deck of cards and the associated suits
(hearts, clubs, spades, and diamonds) we know
and use today in the West originated in France.
The reason why we use this standard so widely
is thought to be because of France's commercial
and cultural influence during the last two
hundred years; undoubtedly the simplicity of
their design played its part, too. The history
of playing cards, however, goes back much
further than this: evidence suggests that they
were first introduced into Europe from Mamluk
Egypt in the late fourteenth century. Going
still further back in time, the first reference to
playing cards is found in ninth-century China.
The suits and the symbols that represent them
may have changed over the years, as well as the
meanings ascribed to them, but playing cards
have remained a popular motif and have a wide-
ranging symbolism attached to them throughout
world cultures.

P

Pocket watch

Since around 2010, pocket watches have been
a very popular design in tattooing. More often
that not, pocket watches are chosen by people
who wish to remember and commemorate an
important time in their life. For instance, many
pocket-watch tattoos will show a memorable
time, such as the time a child was born, or will
use the hands of the watch to indicate an
important date, such as the death of a significant
other. Many such designs also incorporate other
objects that give some further indication of
the nature of what is being commemorated: for
example, hand prints for a new baby or the loved
one's favourite flowers.

SEE ALSO
Cross *p56*
Jesus *p114*

Praying hands

The first thought that comes to mind when
one sees the praying hands tattoo is, of course,
usually associated with religion. However,
while many Christians will indeed turn to this
tattoo as an indication of their faith, it is also
often used as a memorial tattoo to commemorate
the passing of a family member or loved one. The
popularity of this tattoo is not only down to its
simple, striking iconography, but also because
it is easily adapted to make it more personal,
while still keeping the central theme easily
identifiable. As with the Crucifixion motif,
praying hands tattoos were very popular in the
early days of sailing, not only because many
sailors, whether they were men of faith or not,
were highly superstitious, but also because
they believed that their captains, on seeing the
tattoos, would be more lenient with them when
they dealt out any punishment.

P

Q

QR code

Developed in Japan for the automotive industry, the QR (Quick Response) code is the trademark name for a two-dimensional matrix barcode that can be programmed with information that can later be scanned and read. Compared to the original barcoding system composed of vertical lines, QR code can be read more quickly and can hold far more information. Consisting of square dots arranged in a square grid on a white background, QR codes can be read by mobile phones as well as by regular scanners. It is these qualities that have pushed the QR code to the fore, especially within the marketing and advertising industries. It has become a trend to program QR codes with information such as personal contact details and then have them replicated as a tattoo. This means that the QR code can be read by anyone with a smartphone, and the contact information directly uploaded. QR codes can also be programmed to hold crucial medical information such as allergies or emergency contact details.

Q
175

Quincunx

A geometric pattern that is found in many different cultures, the quincunx consists of five points (or dots) arranged in a cross, four of them

forming a square with the fifth placed in the middle. The pattern most commonly appears on dice, playing cards, and dominos, where it represents the number 5, but is also widely found in heraldry and on flags, as well as as a decorative pattern. Thought to have originated in Roman times (where it was a coin), the pattern is widely used within the tattoo world, where it is also known as the five dots tattoo. As a tattoo, the quincunx can symbolize a wide diversity of things. To some it is a fertility symbol, while to others it is a sign that the wearer has spent time in prison – with the outer dots representing the walls of the prison and the inner dot representing the prisoner. In tattoo history, Thomas Edison (1847–1931) – the inventor of, among many other things, the "electric pen", the predecessor to the first tattoo machine (1891) – had a quincunx tattooed on his forearm.

R

Rabbit foot

The act of carrying a rabbit's foot as a good-luck, or protective, charm has been found to exist in many cultures across the world. The belief is often thought to have originated in the Afro-American spiritual practice of voodoo, though Native Americans also have a long history of using this charm. There are certain "rules" to follow to ensure that the charm is effective: it has to be the left hind foot of the rabbit and the animal should be caught or shot in a cemetery. There is no concrete evidence for exactly why the rabbit's foot is considered lucky, though perhaps we can assume that it is down to the characteristics of a rabbit itself: its speed and agility, or its association with fertility (it is a notoriously prolific breeder). In some African folklore traditions, the rabbit is seen as a trickster and this, too, could have contributed to the belief.

SEE ALSO
Bat *p26*
Cat *p44*

Rat

Like the bat, the rat has long had a poor reputation. Since the first recorded epidemic of bubonic plague in the Eastern Roman Empire in the sixth century AD, rats have been viewed, at least in the West, as bringers of death and disease – unclean animals that scavenge and cause

mayhem. For all that, in some cultures and folklore traditions, the rat fares far better. In Asia, rats are seen as creatures that bring good fortune and prosperity, and in some parts of India rats are revered – rats that inhabit certain temples are brought offerings of food and milk. Of course, during the days of sailing, rats were usually viewed with scorn, because they ate supplies and spread disease. Despite that, the rat was worn as a tattoo by sailors as a talisman to ward off bad luck.

Razor

SEE ALSO
Old school *p155*
X*p242*

Straight-edge razors, of the sort that barbers use, were a common old-school tattoo design. The significance of their popularity in the early days of tattooing is uncertain, though it is assumed that, along with motifs such as knuckledusters and switch-blades, they were a symbol of the "tough guy". Often, members of street gangs who worked as enforcers or money collectors would get a razor tattoo as an outward display of their occupation. With the rise, in the mid-1980s, of Straight Edge (X or sXe), a subculture of punk whose followers abstained from alcohol, tobacco, and drugs, the straight-edge razor made a comeback as a symbol of the sXe belief system.

R

179

Realism

SEE ALSO
Dot-work*p66*
Illustrative*p108*
Neo-traditional*p152*
Old school *p155*

Stylistically probably the furthest you can get from old-school traditional tattooing is realism, in which the artist recreates an image exactly as it would appear in real life, rather than stylized, as per old school. Realism is sometimes called portraiture (when the tattoo is of a person), photorealism, or hyperrealism, but they are all the same style and they all follow the same basic

design elements. Realism does not use bold black lines, as do the Japanese or old-school styles, but relies instead on shading and contrast to duplicate the reference image, which more often than not is a photograph. Because the main point behind realism is to create a tattoo that is an exact replica of a real-life subject, it is a style that demands a high level of skill with little room for error. Find an artist who specializes in realism and you will be amazed at the near-photographic fidelity they are able to achieve.

Ribbon

One of the stock objects within tattoo art is the ribbon. Since the early pioneers of tattooing started creating designs, the ribbon has often been a part of the overall motif. Up until recently, the ribbon was often merely used as a method to insert script into a piece, such as across the top or bottom of a tattoo in designs like "Homeward Bound", or across a heart so that a lover's name can be added. With the rise in popularity of the "awareness ribbon", worn to show support for a cause or belief, the ribbon has become a common tattoo in its own right. Many people now get awareness ribbons tattooed on themselves, such as a pink ribbon to show support for breast cancer campaigns or a red one for HIV/AIDS awareness.

Robot

See "Biomechanical'

Rock of ages

The rock of ages is an iconic old-school tattoo design showing a woman clinging to a rock in the middle of a rough sea, with an old sailing ship in

the background and a bible usually somewhere in the design. In the Bible, God is often referred to as a rock, to which believers cling as a refuge, and "The Rock of Ages" was a popular Christian hymn, written in 1763. Because of its nautical theme, its inherent beauty, and religious connotations, sailors soon adopted the image as their own. While the design can vary considerably, the overall meaning is generally clear: no matter how rough life gets, the wearer will always have their faith to cling to. Another possible interpretation is that it represents a life lost at sea, or in sin, with the only way of being saved is through belief in God.

Rooster

See "Pig and rooster".

SEE ALSO
Dove *p66*
Praying hands *p172*
Sacred Heart *p188*

Rose

Of all the symbols for love, the rose must be the most universal and powerful. The simple beauty of the flower has touched the human heart since ancient times, when it was closely associated with goddesses such as Aphrodite/Venus and Isis. A rose bush was said to have grown from the spilled blood of Adonis, Aphrodite's slain love, as well as from the goddess's tears, and was thus a symbol of undying love. In Christianity, the five rose petals symbolized Christ's five wounds, and a rose bush was said to have grown on the site of the Crucifixion. The rose was also closely associated with the Virgin Mary: in Catholicism, the sequence of prayers to the Mother of God is known as the rosary ("crown of roses"). The rose also appears in the tarot, most notably on the cards for The Fool, The Magician, Strength, and Death. These four cards, among other

R

interpretations, are symbolic of transformation, mysticism, and illumination. In England, the rose is the national flower, dating back to the reign of Henry VII (1485–1509), when he combined the red and white rose to form the Tudor Rose, to show unity between the houses of York and Lancaster after the Wars of the Roses. The rose is a flower that has long held the imagination – on the surface a powerful symbol of passion and love, but rich with deeper, esoteric connotations as well.

SEE ALSO
Triquetra *p226*

Runes

Runes were letters used to write Germanic languages, before the adoption of the Latin alphabet we use today. The earliest inscriptions featuring runes date to about 150 AD, only slowly dropping out of use as the peoples of central and northern Europe were introduced to the Latin alphabet by early Christian missionaries. Scholars believe that runes were not used to write down stories or make records, but rather only for sacred or magical purposes, specifically as charms. Though some people believe that runes were used for divination, there is no direct evidence to support this. The very word "rune", meaning "something hidden", suggests their esoteric origins and that their use was once confined to an elite. As modern culture leans towards a greater spiritualism, and with the rising popularity of fantasy and folklore, runes have become increasingly commonplace in tattooing, with wearers assigning their own personal meanings to these simple symbols.

Russian dolls

See "Matryoshka doll".

R

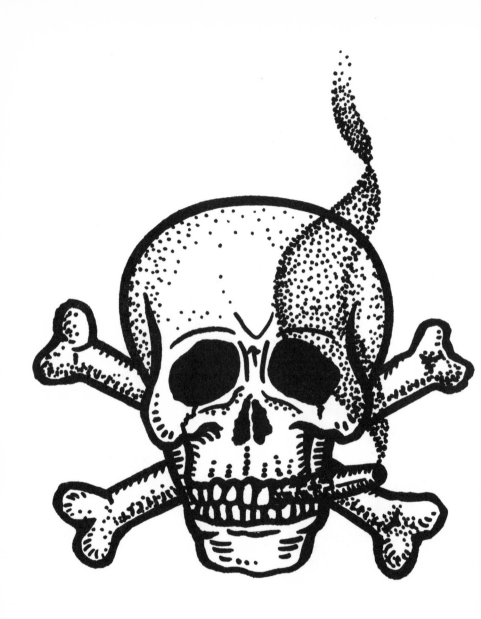

Russian prison tattoos

One of the most complex set of tattoos to have been documented in modern times are those used by criminals in the Russian prison system and formerly by the inmates of the Stalinist Gulags. It is not known exactly when the practice began, but it seems to have been commonplace by the 1920s. Russian prison tattoos tell the wearer's story in comprehensive detail, using not only the motifs and symbols themselves but also their placement on the body. So important are tattoos within this world that bearing "false ink" (unearned tattoos) can incur forced removal of the tattoos, severe beatings, and sometimes death at the hands of the criminal fraternity. An interesting counterpoint to such voluntary prison tattoos are those that are placed on prisoners against their will. Many prisoners are forcibly tattooed to warn other prisoners that they are sex offenders or that they have broken strict criminal codes. Surprisingly, even though most of the tattoos prisoners receive are done in prison and therefore of very poor quality, they can sometimes be hauntingly beautiful, even in their crudeness.

R

187

S

Sacred Heart

The Sacred Heart is a striking motif that has its roots in Christianity but is now widely tattooed purely for its aesthetic beauty. Veneration of the Sacred Heart, which symbolizes Jesus' love for humanity, was first promoted by the Parisian nun Saint Margaret Mary Alacoque (1647–90), after a series of visions in which she reported that Jesus had pulled back his robes to reveal his heart and told her to devote her life to the Heart of Christ. Iconographically, the Sacred Heart is usually encircled with a crown of thorns and surrounded by flames and a divine light. A later, related motif was the Immaculate Heart of Mary, in which a heart is shown pierced by swords, representing the Seven Sorrows. The Sacred Heart has evolved into many different forms over the years and is still a very popular theme in tattooing.

Sailor's grave

A popular design among early sailors, the sailor's grave tattoo incorporates different stylistic symbols, with the core of the design being a sinking ship, still visible above the waves. This design serves as both a memorial, or commemorative, tattoo for fellow sailors and friends lost at sea, as well as as a good-luck tattoo.

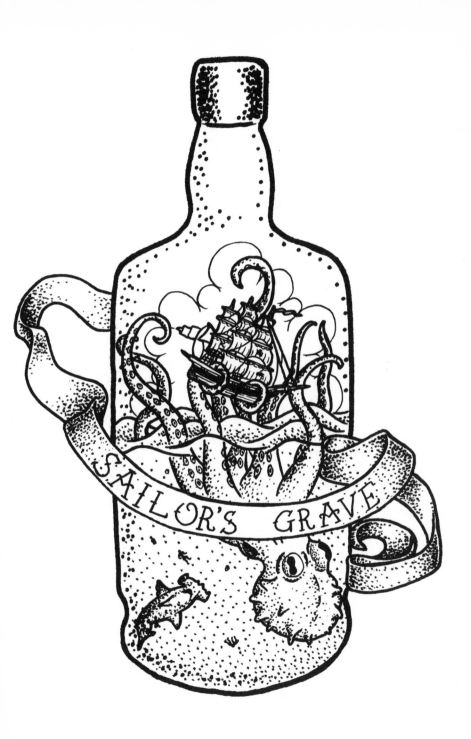

Sailors believed that having what they most feared tattooed onto their body would prevent that event happening. Psychologically, we might see the tattoo as a way for sailors to face their fears, a means of coming to terms with the threat of death that they faced every day. Often, the design also incorporates a shark or some other seafaring danger, showing the forces that a sailor had to overcome if he were to live a long life.

SEE ALSO
Angel *p18*
Sword *p212*

Saint Michael

Much revered in Christianity, the archangel Saint Michael is one of only two angels mentioned by name in the Bible. In the Book of Revelation, it is Michael who leads the battle in heaven against Satan and the fallen angels. For this reason, Saint Michael is often depicted as a warrior in armour, brandishing a double-edged sword, and with his defeated enemy – who often takes the form of a dragon – at or under his feet. His image is popular not only as a religious tattoo but also as a reminder that we must be strong and courageous in life. Because of the archangel's role as protector of Christians and the Christian Church, the motif can also serve as a talisman, protecting the wearer from harm or evil.

S

191

Sakura

See "Cherry Blossom".

Sak yant

A form of tattooing that originated in South-East Asia some two thousand years ago, sak yant tattoos are hand-etched into the skin using a long sharpened piece of bamboo or long metal rod, and comprise mystical designs of animals, deities,

and geometric motifs, along with Buddhist prayers written in the sacred Pali language. In ancient times, Buddhist monks tattooed warriors with sak yant tattoos prior to battle, as they were thought to give the wearer magical powers and were associated with luck, strength, healing, and protection from evil. Nowadays, the tattoos are worn more generally by Buddhists, especially in Thailand. Often, the tattoos cover the entire body, as it is believed that the higher up the body the tattoo is placed, the more auspicious and powerful the tattoo will be. The power of the tattoos is said to dwindle over time, so practitioners and devotees meet once a year at a ritual festival where the tattoos' power is restored. In the West, sak yant designs are often applied by Western tattoo artists who have little idea of the meanings behind the motifs or their placement, so many people prefer to travel to Thailand to receive an authentic sak yant tattoo from a master practitioner.

S

192

Sanskrit

Sanskrit, meaning "refined speech", is the ancient sacred language of Hinduism and is still used today for ceremonial purposes in Hindu rites as well as for some Buddhist hymns and chants. It was also the literary language used to write some of India's greatest works of literature and philosophy. When written, Sanskrit has a beautiful, swirling form that is aesthetically pleasing to the eye and for this reason – as well as because of the importance of Eastern religions in New Age spirituality – it has become a popular script to use in tattoos. As with Japanese kanji, there are inherent problems to this. First, unless you are tattooed by an artist who is fluent in Sanskrit there is a high possibility that the

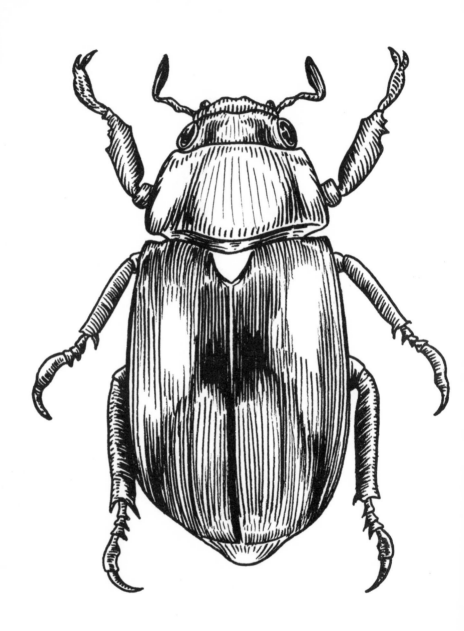

meaning of the tattoo will be far removed from what you intended. Secondly, since Sanskrit is a sacred language, there is the strong possibility that the tattoo will be offensive to some.

Scarab beetle

In the early Middle Kingdom of ancient Egypt (2000–1700 BC), scarab beetles became common as a motif used on amulets, jewellery, and personal seals, and remained popular in Egyptian culture and mythology from then on. The Egyptians held the scarab beetle in high regard, venerating it because of its associations with Khepri, the god of the rising sun. Each day, Khepri rolled the sun across the sky and then through the underworld so that it could be reborn the following day. Similarly, the scarab beetle was observed to roll balls of dung into its nest, where, the ancients believed, it would fertilize them with its semen and thus propagate its young. For this reason, the scarab was closely associated with rebirth, resurrection, and transformation.

Scratcher

The tattoo world's greatest enemy, a scratcher, is someone who carries out tattooing illegally and usually has no artistic ability. Typically, the scratcher does not work in a studio setting and pays little or no heed to the health and safety of clients. Of course, many bona fide tattoo artists start out working from home or begin by practising on their friends – there are many world-class tattoo artists who began their careers this way – but the difference between them and a scratcher is that, while their artistic abilities increase and improve with practice, the

S

scratcher's hardly ever does. The bona fide artist is eager to learn and is prepared to work hard so that they can set up their own studio, while the scratcher remains where they are, content with raking in money, without really caring about whom, what, or where they tattoo. Besides getting poor-quality work artistically speaking, the client also runs a high risk of infection, as, more often than not, scratchers do not follow the legal health and safety requirements.

Script

SEE ALSO
Kanji *p119*

Also known as lettering, script covers anything from a single word to a quote. Script can be rendered in a wide range of fonts, but true-quality script work often uses old-style fonts such as Gothic or Old English, and is embellished with flourishes and intricate line work. A tattoo artist who is highly specialized in script work will often only work in this style and will be able to free-hand the tattoo straight onto a client's skin, without the need for a stencil. The commonest mistake made by artists when doing script is that the finished piece is illegible: however embellished or detailed the script, it should always be possible to read what has been tattooed. With script work, more than in any other style, it is very important to check that what is put on the skin is correct: a missing or misplaced letter can totally change the meaning of the tattoo, such as in the words "angel" and "angle".

Semicolon

SEE ALSO
Razor *p179*
Ribbon *p180*
Sobriety Circle *p201*
X *p242*

A relatively new symbol in tattooing, and what could be considered a fad or fashion tattoo, the semicolon gained popularity after 2013 when the SemiColon Project was launched in

the United States. The SemiColon Project is a charity that was set up to help people who are suffering from depression, anxiety, and other mental health issues, its name deriving from its ethos: "A semicolon represents a sentence that the author could have ended, but chose not to. The author is you and the sentence is your life". A social media campaign encouraging supporters to draw a semicolon on themselves and then to post the image on a social media site quickly caught on and soon people were opting for a more permanent way of showing their support by getting a semicolon tattoo. This, in turn, led to the formation of the Semicolon Tattoo Project. The global reach of social media and the ease with which ideas like this can go viral have meant that many similar tattoos have gained popularity since the semicolon first came to prominence.

SEE ALSO
Celtic cross *p47*
Jack-o'-lantern *p113*

Shamrock

The shamrock is the term used to describe a young sprig of clover, usually with three leaves (the word derives simply from the Gaelic for "little clover"). The motif was early on associated with the early Christian missionary Saint Patrick who is said to have used a three-leaved leaf of clover as way of explaining the mystery of the Holy Trinity ("three in one") as he travelled through Ireland converting the local inhabitants. Depictions of Saint Patrick often show him bearing the shamrock in one hand, while the other holds the staff that he used to drive the snakes out from Ireland. Since the eighteenth century the green shamrock has been used as a national symbol for Ireland and its people. In its rare four-leafed form, the clover is a token of good fortune, the four leaves representing faith, hope, love, and luck.

Ship

See "Homeward Bound".

Sigil

A sigil is a term used to refer to a type of magical symbol that is supposed to represent the signature of a demon or entity. In modern magic circles, it is used to express the desired outcome of a magician. The word derives from the Latin for "seal", though it is also thought to relate to the Hebrew word "segula", meaning "word, item, or action of spiritual effect". Though sigils are ancient in origin – the use of symbols representing occult spells, rituals, or practices being found as far back as Neolithic times – modern sigils can be found in many beliefs and spiritual walks of life, from paganism to Satanism. Because the act of creating a sigil, outside of an occult system, is merely to create a simple symbol to represent a idea, wish, visual identity, or action, sigilism has become a popular way to represent, and then reduce, a complex set of beliefs or actions into a single symbol. In a way, logos such as the Nike Swoosh or McDonald's Golden Arches are modern-day sigils in that global companies rely on a symbol to represent a broader, more complex idea.

Skull

While the skull universally represents death and decay, a life passed, it can also have more positive connotations. We cannot help but look upon the skull and not retain a sense of our own existence and our place in the world; think of Hamlet and his famous soliloquy to Yorick. In outlaw cultures, such as those of pirates and biker gangs,

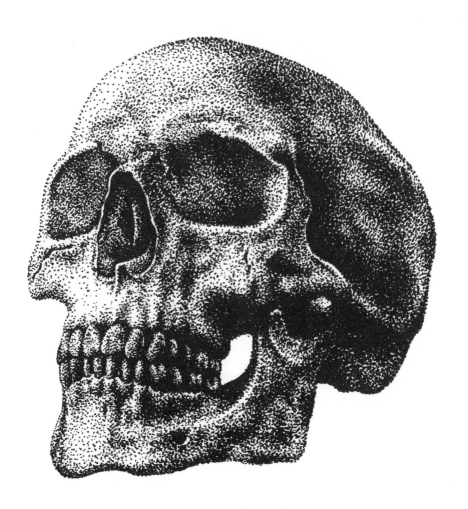

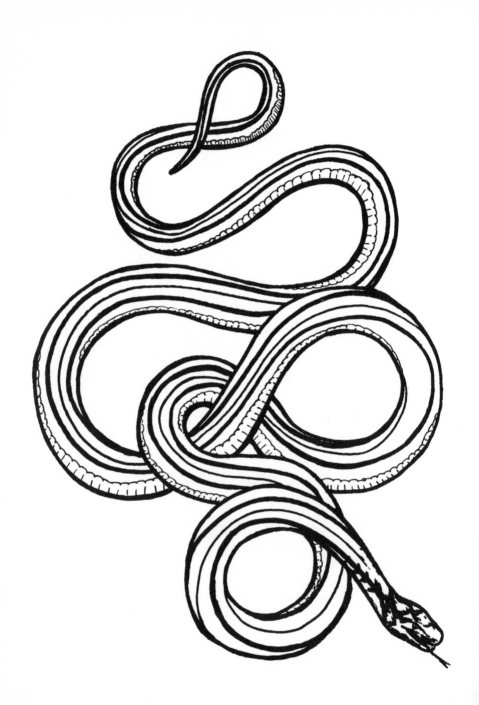

the skull has traditionally been used as a sign of rebellion, as well as a means to strike fear into the hearts of those who view this powerful image. In art, it has sometimes been used to represent secret knowledge or the truth, as in its anamorphic presentation in Hans Holbein's painting *The Ambassadors* (1533). Today, we still use the skull and crossbones as a symbol warning of poisonous substances. The skull represents both death and life – it quite literally hides knowledge but in the end reveals the truth.

Snake

To fully cover the symbolism and mythology of the snake would probably take up a book on its own. It is one of the oldest and most powerful symbols in human civilization, and can be found in nearly every culture and mythology. Around the world, and through history, the snake has come to represent many different ideas – from the duality of good and evil to fertility and secret knowledge. Because a snake is able to shed its skin, it is also seen as a symbol of rebirth and regeneration. Some religions revere the snake as a representation of a deity, while other religions, such as Christianity, view the snake as an evil entity bent on bringing ill fortune, sin, and chaos to the world. Ultimately, the snake is a powerful symbol in the human psyche and, therefore, a popular design choice for tattooing.

Sobriety Circle

Although the triangle with a circle around it is today most commonly seen as the symbol of Alcoholics Anonymous (AA), it is in fact an ancient symbol that can be found depicted in many old images as well as described in old texts.

There is no definitive explanation for this symbol but, like so many ancient symbols, it has been adopted by various cultures and belief systems and adapted to explain their particular ideas. For members of AA, the triangle represents unity, recovery, and service – the answer for a three-part disease that is physical, mental, and spiritual – while the circle represents oneness. Many people who have beat alcoholism get this symbol as a tattoo, a daily reminder of their journey of recovery. Interestingly, fans of J K Rowling's "Harry Potter" books sometimes get a very similar symbol – there is the addition of a vertical line – as a tattoo. The circle, triangle, and line represent the Deathly Hallows.

Spider web

Over the years, the spider web has become a popular tattoo far beyond the world of convicts, criminals, and prisoners, but within the walls of the prison the spider web has very significant meanings and is one of the very oldest prison-code tattoos. At the most basic level, the tattoo represents an inmate doing time and was traditionally positioned on the wearer's elbow(s): the prisoner has been sitting around with their elbows on a table for so long that spiders have made their homes there! In some prison subcultures, the number of concentric circles within the web represents the years spent behind bars. Within the Russian prison system, a plain web indicates the wearer is a thief, while having a spider in the web means that the inmate is a drug addict. In this last instance, the tattoo is usually located on the hand, between the thumb and index finger. Sometimes, a spider-web tattoo is used to show that the wearer has committed murder while in prison.

Spiral

The spiral is a shape that is found everywhere in nature and has always been a strong artistic design element through history. In New Zealand, the Maori have a pattern they use in tattooing that represents a spiral, the *koru*. Based on the shape of a young, unfurling silver fern, the *koru* is said to represent new life, growth, and harmony. It is also representative of the future and the past, the person bearing the *koru* showing that they will carry the values of their ancestors forward into the future of their youth. The so-called Golden Spiral is related to the Golden Ratio (symbolized as π): the spiral gets wider by the factor of π with every quarter-turn, creating a strikingly beautiful line. The Golden Spiral occurs everywhere in the universe – from the growth of plants to the formation of galaxies. Since the Renaissance, some artists have believed that the proportions contained within the Golden Ratio hold the secret of beauty and used its principles to create "perfect" art. Leonardo da Vinci (1452–1519), for example, is sometimes argued to have used the Golden Ratio when creating the composition for his wall-painting *The Last Supper* (1494–9).

S

204

Square and compasses

There are many symbols associated with Freemasonry, but the most widely known is probably the square and compasses motif. As the name suggests, the design comprises a square and a set of compasses that are joined together, each leg of the compass pointing in opposite directions. The square is a symbol of morality, while the compasses represent a Mason's boundaries. As a combined motif, the square and

compasses tells a Mason that, just as a building needs a solid foundation (based on accurate measurements and so forth), so, too, must a Mason create a spiritually solid basis on which to build his life. Often, the square and compasses will have the letter G incorporated into the centre. This is a reminder that every action that a Mason undertakes is observed by God.

Stag

See "White stag".

Star

See "Crescent moon and star", "Nautical star", and "Pentagram/pentangle".

Star of David

One of the most iconic symbols of Judaism, the Star of David – created from two overlaid equilateral triangles to form a six-pointed star or hexagram – is traditionally supposed to represent the shape of King David's shield (in Hebrew, the Star of David is known as the "Shield of David"). For all that, it has a relatively short history as an explicit symbol for the Jewish faith, and when found in early Jewish art seems to have had only a decorative function. It was only in the nineteenth century that it began to be adopted by Jewish communities in Eastern Europe as a symbol of their faith, and only after 1897, when the First Zionist Congress chose it as the central symbol of the new Zionist flag, did its use spread to the wider Jewish community, to represent Jewish identity and faith. Some Orthodox Jewish groups reject the hexagram as a symbol because of its association with magic.

Steampunk

A subgenre of science fiction and fantasy, steampunk is easily identifiable as it is usually set in the past, yet the mechanical and technological objects within the illustrations and stories seem from a future time. For example, a story might be set in the Wild West, yet the characters might use modes of transport or weaponry that only came into being much later in the evolution of technology. Another aspect of steampunk is that this technology, more often than not, is portrayed as relying on steam, or forms of power other than electricity. Steampunk has crossed over into tattooing, where it seems to have found a resonance with the biomechanical style. This is largely due to the idea that one of the basic principles of biomech is that the internal parts of the body (muscles, joints, organs) are replaced with mechanical or alien parts. Combine that principle with steampunk, whose art often depicts technology that features clockwork mechanisms such as springs, cogs, and dials, and it is easy to see how the two can be combined.

Straight Edge

See "X".

Sugar skull

Every year, from 31 October to 2 November, Mexicans celebrate the Day of the Dead – the *Día de Muertos*. This ancient annual festival was a chance for people to celebrate life, death, and rebirth, and to commemorate and honour their ancestors who they believe returned to earth at this time to visit them. A colourful, joyous time, the Day of the Dead is not supposed to be

S

207

morbid or even associated with death; rather, it is seen as a celebration of the past. One of the best-known traditions of the festival is to offer the dead brightly decorated skulls made out of clay or sugar. As a motif, this has been adopted as a tattoo and has spread out to the rest of the world.

Sun

Worshipped as long as there has been human life on earth, the sun is a universally revered symbol and motif the world over. There is not a culture or religion on earth that does not look to the bright yellow star in the daytime sky and not associate it with life, energy, strength, and rebirth. It is the all-powerful source of everything that lives on the planet, a guide to travellers, and a means to tell the passing of time. Numerous mythologies bear witness to the central place the sun has played in belief and religion – from the ancient Egyptian Ra to the ancient Greek Helios, and right through to modern spirituality, where the sun is seen as a personification of life, that which sustains the natural world and which makes existence on earth possible. The sun is the start of a new day, brings light where there has been darkness, promises growth, change, and transformation... And of course, once an object has settled itself so deeply in our psyche, it isn't long before it is reflected in our art, whether that's on our skin or off.

Swallow

One of the most iconic nautical tattoos, the swallow has long been used by sailors to show their experience on the sea. Though many different legends circulate about the origins of the motif, the most common belief is that it

represents having travelled over 5,000 nautical miles; having two swallows, naturally enough, represented 10,000 nautical miles. Another belief is based on the fact that the swallow always returns home to nest; therefore, having a swallow tattoo was a form of talisman for a sailor: they, too, would eventually return safely to their home port after a long journey. Often, a sailor would get one swallow on his outward journey and another once safely back home. Another legend states that, if a sailor died at sea, birds would carry his soul to heaven – another reason to have this important symbol by one constantly. The swallow was traditionally tattooed on the chest, hands, or neck.

Swan

SEE ALSO
Angel *p18*
Dove *p66*
Feather *p80*
Valkyrie *p232*
Wings *p238*

In Celtic traditions, swans represent love and purity of the soul, though they are also believed to be shape-shifters, able to take on human form. Throughout Irish folklore, swans are often the form taken by fairy women, and on certain sacred days, such as Beltane and Samhain, when the veils between the worlds are thin, they are able to change into human women. For the ancient Greeks, the swan was a symbol of the Muses – the goddesses of the arts – while the Norse believed that valkyries often took the form of swans, as they flew through the air. No matter which culture in which the swan appears, it is always as a powerful spiritual emblem – graceful and otherworldly, it is an eternal symbol of purity.

Swastika

SEE ALSO
Peace sign *p165*

Today, no symbol is more notorious than the swastika, but it is also the most maligned. Appropriated by the German dictator Adolf

Hitler (1889–1945) as a powerful symbol for the National Socialists (Nazis), the swastika had previously been in use for millennia as a symbol of peace; indeed, it is still commonly used as a religious symbol in Hinduism and Buddhism. The very word for the emblem derives from the Sanskrit word *svastika*, which means a lucky or auspicious object, and often followers of these religions will have the swastika tattooed on them as a lucky talisman. Because of its use by the Nazi Party, the swastika's true meaning has been subverted and it is now used by white supremacist groups. Nonetheless, there is a strong movement around the world to "claim" back the symbol as a symbol of peace.

Sword

The motif of the sword instantly evokes ideas of protection, courage, and strength; we think of the knight in shining armour going into battle to save the land or to rescue a persecuted maiden. Many warrior peoples such as the Saxons viewed the sword as an extension of their being – to relinquish it was not only to be dishonoured but to lose one's identity. However, the sword also has plenty of metaphysical and philosophical associations as well, no doubt in some part linked to these surface meanings. In alchemy, the sword is a symbol of purification, piercing the spiritual soul of man, while in Buddhism the sword is used to cut away the earthly bonds of man so that he may receive enlightenment. Swords are seen as powerful talismans, given to folklore heroes so that they can carry out their quests: the young Arthur wins Excalibur and thus asserts his right to be king, while the Greek hero Perseus is given a sword by his father Zeus, so that he can kill the monstrous Medusa.

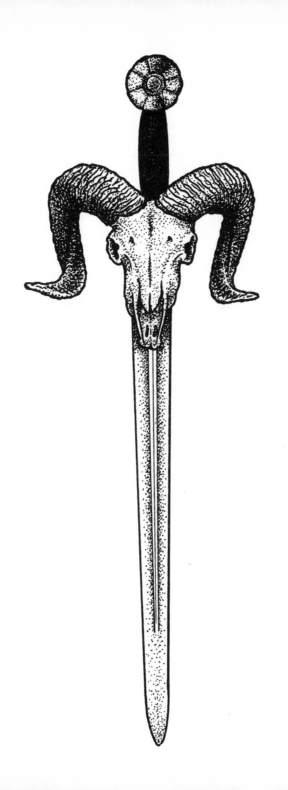

Ta moko

Ta moko is the traditional form of permanent body art used by the Maori people of New Zealand. It is different from tattooing in that ta moko is applied using a chisel method, rather than puncturing the skin with needles, as is done in traditional tattooing. Because of this procedure, furrows or grooves are left in the skin, rather than the flat skin surface that is achieved in tattooing. The main focus of Maori tattooing is the face, as these people deem the head the most sacred part of the body. The lines, symbolism, and placement of Maori tattoos are very complex, and the rituals involved when receiving a tattoo can last many days. Though ta moko tattoos may look like random patterns, they in fact tell a complex story of the wearer's lineage, rank, and achievements. Ta moko is a sacred art form for the Maori and is traditionally performed under strict conditions and rules and by "artists" of high rank, people whom, in the West, we would consider to be shamans.

Teardrop

Originally worn to show other gang members or prisoners that you had committed murder, the teardrop (usually tattooed under the outer corner of the eye) is now widely used to symbolize

the loss of a family member or close friend. One of the most common prison tattoos, the teardrop has come to symbolize many different things to inmates around the world. Depending on culture and geographic location, it now has various meanings, including showing that you have been raped while serving time or that you have had a sad life. In some circles, the outline of a teardrop (i.e. one that is not fully shaded) is used to show that someone close to the wearer has been unjustly killed and that they are seeking revenge. Once the revenge has been carried out, the teardrop is completed by being filled in.

Tebori

SEE ALSO
Sakyant *p192*

Tebori is the traditional machine-less method of tattooing that originated in Japan in the early nineteenth century. Steel needles are arranged in rows, on their own or stacked, then attached to a bamboo stick and inserted under the skin with the forward movement of the artist's arm. Using this method, tebori masters are able to replicate intricate designs with extremely subtle gradients of shading. Like all Japanese tattooing, tebori are richly layered pieces of art in which individual symbols and motifs are combined to form a larger work. Even the backgrounds of tebori tattoos are important, often signifying just as much as the major and secondary images. *Shakki* is said to be the sound the tebori needles make as they leave the skin.

Thistle

SEE ALSO
Crow *p56*
Fleur-de-lis *p86*
Jack-o'-lantern *p113*

According to legend, during the reign of the Scottish king Alexander III (1249–86), one night a horde of Norse warriors were sneaking up on a Scottish encampment when a Norseman cried

out in pain after standing on a thistle, thereby alerting the Scottish army that they were under attack. From then on the plant became known as the "Guardian Thistle". Though there is no historic evidence to back up this story, it was enough to ensure that the thistle became the national emblem of Scotland as well as of the Scottish order of chivalry, the Order of the Thistle. It is not only in Scotland that the thistle is viewed as a protective plant: both in France and Spain it is said to ward against witches. Due to its purple colour, the thistle is also often associated with royalty and high rank.

Three dots

This simple tattoo design – three dots in a triangle located on the outside of the hand between the thumb and forefinger – is usually associated with gang culture. Though it is most frequently used by Hispanic gang members, for whom it signifies "Mi vida loca", or "My crazy life", many other gang members also have the three-dot tattoo. In Germany, it simply means that the wearer has served time behind bars. If you look further back, three-dot tattoos were used by sailors as a protective talisman. As with most iconography, especially ones that are as simple as this, its meaning changes according to location and across history. You have only to dig a little deeper to find that, in France, Russia, Turkey, and many other countries, there are still further meanings attributed to this tattoo. In parts of France, the three dots stand for "Mort aux vaches" meaning "Death to cops" (*vaches*, or cows, being a derogatory word for policemen), while in Turkey it is said to mean, "I hear nothing, I see nothing, and I tell nothing."

T

217

SEE ALSO
Cat *p44*
Dragon *p67*

Tiger

It is easy to see why tigers are such a popular choice when getting a tattoo. They are the largest of all the big cats and their physical presence instantly invokes strength, beauty, and sensuality. In China, the tiger is considered the ultimate land animal, surpassing even the lion as the king of the beasts. The tiger is also associated with wealth, courage, and long life, but is also, somewhat paradoxically, seen as the protector of the dead. Tigers are considered one of the four sacred animals in China, the universe being held in balance by five tigers of different colours, each one representing an element and a season, with the fifth being born of the sun, to rule the others. In India, the tiger is seen as having supernatural powers, able to fight dragons, create rain, and prevent children from having nightmares. A creation myth in Korea centres on a fight between a tiger and bear as they vie for the right to become human. The tiger fails, fleeing into the forest, while the bear wins and becomes the first woman, the ancestress of the Korean people.

SEE ALSO
Fish hook *p83*

T

218

Tiki

In Maori mythology, Tiki was the first man, though the story surrounding him and how and why he was created varies, depending on which Polynesian culture you delve into. Tiki is also the name given to a type of large wooden carving with human features that is used to mark the boundaries of sacred or special sites. Finally, the name is also given to a kitsch, pseudo-Polynesian culture that has become popular around the world, especially in the United States, where bars, shops, and restaurants are decked out with Tiki carvings and decorated with bright colours,

flaming torches, and rattan furniture. There are Tiki cocktails served in Tiki mugs while Tiki music – a blend of jazz and Polynesian and other exotic sounds – plays in the background. And then, of course, there are Tiki tattoos...

Tomahawk

SEE ALSO
Arrow *p21*

As with many Native American designs and symbols, the tomahawk has had peaks and troughs of popularity as a tattoo choice over the years. The symbolism of the tomahawk among Native American peoples is interesting and adds a duality to a design we might otherwise simply associate with warfare. In Native American culture, when a war council was convened, a tomahawk was placed on the ground in front of the tribal elder or chief. If it was decided that a war party was to be raised, the chief would pick up the tomahawk and get his tribe ready for battle, usually through a ritual of song and dance. If, however, they decided not to go to war, the tomahawk would be buried under the ground – the hatchet quite literally buried. Tomahawks were used in most important ceremonies and often had a hollow stem at one end that was used as a pipe for smoking.

Tombstone

SEE ALSO
Spider web *p202*

As humans, we are always obsessed with our own mortality. Tombstones are popular images, as they serve to remind us that time is short and that we need to make the best of our lives, and maybe, too, as a way of warding off death. With the rise in popularity of zombie culture, the tombstone is an even more pertinent symbol of life, death, and rebirth ... or just maybe a bit of fun to show your allegiance to a new subculture. In prison terms,

T

the symbolism is as simple as the imagery – dead, or wasted, time. Sometimes dates are added to show the term served. In some prison cultures, it is representative of the lifer, someone "in for life" or who has no chance of parole – literally, and symbolically, a dead man walking.

Totem

SEE ALSO
Bear *p29*
Panther/jaguar *p162*

A totem is an object or animal that a tribe, people, culture, lineage, or family use to represent themselves spiritually, as well as an emblem to remind them of their ancestors and their mythical past. Though the word originates from the language of the Native American Oijbwe people, totems are not limited to Native Americans and can be found in many cultures outside of America. In New Age spiritual circles, many believe in the idea of spirit guides that take the form of animals or birds, this idea having been adopted from the original idea of totems. Totem poles, which function as family crests, though strongly associated with Native Americans, can also be found in other parts of the world such as China and Korea.

Trash Polka

SEE ALSO
Realism *p179*

Described by one of its creators as combining "realism and trash, nature and the abstract, technology and humanity, past, present and future", Trash Polka is a style of tattooing created by two tattoo artists from the Buena Vista Tattoo Club in Germany, Simone Plaff and Volko Merschky. Trash Polka combines natural or photorealistic images with geometric graphics and lettering. Major design elements of this style are minimal use of colour (generally just red and black) and use of negative space – that is, areas of

uninked skin that play an important role in the tattoo. Another characteristic of a Trash Polka tattoo is that it usually covers large areas of the body – whole backs, legs, or chests and stomachs. Trash Polka has spread throughout the world, but it is generally agreed that a tattoo is not truly Trash Polka unless it is done by Simone or Volko.

Tree of Life

The Tree of Life is a global archetype that can be found in biology, mythology, religion, and philosophy. In a biological context, the naturalist Charles Darwin (1809–82) used it as a metaphor for the evolution of all things on earth, while many religions use it to show the connectivity between the world we live in and other, spiritual planes. As far back in history as ancient Egypt and ancient Iran, the Tree of Life was used to show how the universe, and all living beings in it, came into existence. In Buddhism, Buddha received his enlightenment while resting under the Bodhi tree. In Norse mythology, the immense ash tree Yggdrasil connects the nine worlds. In the Kabbalah, the Tree of Life is representative of different inconnected nodes, or principles, that are the core of Jewish mysticism.

T
225

Tribal

As the name suggests, tribal tattoos are based on designs and elements that originate from tribal peoples around the world, most notably those belonging to Polynesian, Maori, and Bornean cultures. In a phenomenon that first peaked in the 1990s, tattoo artists took the big, sweeping, body-contour-fitting tattoos typical

of such areas and combined them with their own interpretations to come up with a style that was instantly recognizable. Keeping the big, bold, black lines that used the body's musculature to determine flow and size, artists simplified the complex designs and removed the repeating patterns. As this style continued to evolve, artists went back to the tribal styles and started incorporating these intricate patterns back into their designs, taking tribal back closer to its original inspiration. Today, you can find central stock images such as lions, or even portraits, used in conjunction with tribal to create a more detailed finish. But the key elements are always thick lines, lots of blackwork, and the absence of colour.

SEE ALSO
Celtic cross *p47*
Shamrock *p197*

Triquetra

This Celtic motif and symbol – whose name means simply "three-cornered shape" – has many different layers of meaning attached to it. Originally, as found on Celtic crosses and in illuminated manuscripts such as the *Book of Kells* (created in about 800), it seems to have been merely decorative, but was later used as a symbol for the Trinity – the Father, Son, and Holy Ghost. In origin, it may be related to the Norse symbol known as the Valknut, which symbolized the most powerful Norse god, Odin, and it appeared on early Germanic coins as well as rune stones. Today, neopagans such as the followers of Wicca use the triquetra to represent the Triple Goddess, in her guises as maid, mother, and crone. With the number 3 considered one of the most powerful or sacred numbers in most religions and cultures, the triquetra has been picked up by many different belief systems and adapted accordingly to those specific beliefs.

Triskelion

Found as a motif in a number of prehistoric cultures, the symbol known as the triskelion (from the Greek for "three-legged") is composed of three interlocking spirals that rotate outwards from a central point. As with many ancient symbols, there is no definitive interpretation for the triskelion, though it is clearly associated with dynamic forward movement, and with energy, momentum, and cyclical motion. Because of its three-part form, the symbol can also be related to triadic spiritual or philosophical concepts – life/death/rebirth; mind/body/spirit; and past/present/future. Combine these two explanations and a third is found, in which it represents the forward movement to a higher spiritual understanding. A similar, if more pictographic, design, shows three hares chasing one other in a never-ending circle.

Tumbling blocks

The motif known as the tumbling blocks, or, more technically, as rhombile tiling, has appeared in various artistic media for millennia. Nowadays, we look upon this mind-boggling design simply as aesthetically pleasing, especially because of its ability to be used as an interlocking repeat pattern. However, tumbling blocks have a rich history in their own right. Examples of the tumbling blocks motif have been found in ancient Greek floor mosaics on the island of Delos as well as in medieval Italian floor tiling. In the mid-nineteenth century, quilts using the tumbling blocks design were famously used on the "Underground Railroad", the system of safe houses and secret routes used by escaping African-American slaves in the nineteenth

T

century. Slaves would create quilts that acted as encoded messages to other slaves, relaying various pieces of information such as the location of safe houses and the direction of travel. If a quilt hung out on a fence featured tumbling blocks, then it was high time for the fugitive to literally "box up" their possessions and continue on their journey to freedom.

Turtle

SEE ALSO
Tiki *p218*
Tribal *p225*
Waves *p235*

In Polynesian culture, a turtle represents the link between this life and the next. Because turtles can move freely from land to water, the Polynesians believe that the turtle will help them move to their final resting place. In Hawaiian mythology, a turtle guided the first indigenous people to the islands and therefore is revered as a navigator. The Hawaiians also believed that their guardian spirits would take the shape of animals and that they would often assume the form of a turtle to protect children playing near the sea. Turtles are found in many of the islanders' artworks and tattoos, often incorporated into bigger designs or with a basic outline containing many intricate shapes and patterns. In the world of seafaring tattoos, a shell-back (turtle) tattoo shows that the wearer has crossed the Equator.

U

Unalome

In South-East Asian Buddhism, the unalome was a symbol that an arhat (someone who has reached nirvana or spiritual perfection) received to show that they had successfully followed a path to enlightenment. The symbol is a visual representation of an individual's spiritual journey, which starts in the centre of the unalome – the spiral – and ends at the top of the unalome – the straight line – where you have finally attained enlightenment.

V

Valkyrie

SEE ALSO
Angel *p18*
Swan *p211*

In Norse mythology, the valkyries were a host of female spirits who roamed battlefields deciding who would live and who would die. Having made their choice, they would then conduct the fallen warriors to Valhalla, the Hall of the Slain, to present to the god Odin. Because it was believed that valkyries only chose the best warriors to be taken to Valhalla, it was an honour to die bravely in battle. In Norse stories, valkyries were sometimes shown as the lovers of heroes or as the daughters of royalty, and were often depicted on horseback or accompanied by ravens, or sometimes in the guise of flying swans. Valkyries were considered brave and great warriors, able to regenerate themselves when wounded in battle.

Vegvísir

SEE ALSO
Runes *p184*

Although of some antiquity, the Vegvísir (Icelandic for "guide post") is attested only in a small number of old Icelandic manuscripts. Sometimes called the Runic Compass, it is believed to have its origins in medieval mysticism, with some connections to Germanic runic traditions, and was used as a talisman to help a person find their way in rough weather. As a tattoo, albeit simplified, it famously adorns the Icelandic singer Bjork.

Vitruvian Man

Leonardo da Vinci's drawing *Vitruvian Man*, which dates to about 1490, has been held in awe for centuries and is surely one of the most hotly debated pieces of art in existence. In it, Leonardo displayed his deep knowledge and understanding of the human form and of its proportions, in which he took a keen interest both as a painter and as a philosopher. Leonardo took his inspiration for the drawing from the writings of the ancient Roman architect Vitruvius, creating a diagram that, without resorting to numbers, was able to express perfectly how the human body's separate components are all mathematically related to the whole. Ostensibly a simple visual image, *Vitruvian Man* has complex layers of meaning, showing how symmetry and proportion can be found not just in man but throughout nature. In latter years, *Vitruvian Man* has become a symbol of how we are one with nature and how everything in the cosmos is divinely and mathematically interlinked.

Watercolour

As with traditional watercolour paintings, the watercolour style of tattooing is based on free-form painting, but uses bright, vibrant colours and can often be quite abstract. Commonly, a watercolour tattoo will have a central subject that is rendered in either a stylized or realistic manner and will then have splashes or brush-strokes of colours layered on top of, or around, it. There is debate within the tattoo world whether watercolour tattoos will hold their form on the skin over time. Some argue that, because there are no defined lines or recognizable patterns used within watercolour tattoos, tattoos done in this style will eventually degenerate into a mass of shapeless colours. The same was said about tattoos in the realist style when they first came to the fore, but time has since proven the prediction to be incorrect.

Waves

As with most tribal tattoos, the overall design of a tattoo can be broken down into various symbols and patterns that mean just as much on their own as the complete motif. For the Polynesian people, the ocean is a very important part of their culture. Not only is it one of their main sources of food, it is also where they believe they return

W

to when they die. Thus, the ocean represents not only death but also life and fertility – in short, it encapsulates a complete life cycle for these seafaring people. In the Polynesian tattooing tradition, ocean waves are often found as a repeating pattern to fill in gaps or to create a border. In a similar vein, waves are important within Japanese tattooing. Though their inclusion is sometimes explained as a symbol of the ebb and flow of life, waves seem often to be used simply as background filler – using the body's musculature to help give the main subject flow, depth, and placement.

White stag

SEE ALSO
Cross *p56*

In Celtic mythology, the white stag is a sign that the otherworld is near, that a spiritual quest is about to begin, or that a profound change is about to occur for the person who has witnessed it. In Arthurian legends, a white stag, or hart, quite often appears when the knights set off on their adventures. In Christianity, the Roman soldier-saint Eustace saw a vision of a white stag with a cross between his antlers while out hunting, and thus the motif became a symbol of Christ. An enduring symbol in mythology, the white hart has continued to feature in more modern writings, as in the C S Lewis children's novel *The Lion, the Witch and the Wardrobe* (1950) and in J K Rowling's "Harry Potter" novels, where the young magician hero has a "patronus" (protector spirit) in the form of a white stag.

Winged skull

SEE ALSO
Skull *p198*
Wings *p238*

A skull with wings is one of the most common designs used by motorcycle clubs and gangs around the world. Back in the 1930s, motorcycle

culture boomed and with it came the view that bikers were modern-day pirates or outlaws. At the time, the prestigious US motorbike manufacturer Harley-Davidson came up with a marketing ploy to capitalize on this and created the winged-skull logo. The logo quickly caught on and soon motorcycle gangs, most notably the Hells Angels, began adopting it as their own. Besides its links with "one-percenter" motorcycling, the winged skull is quite an old design and can be found on many early gravestones, where it is thought to represent the fleeting nature of life and the endless cycle of life and death.

Wings

Wings have a special place in the human psyche. Not only do we associate them with angels, and therefore see them as protective; we also associate them with birds and the freedom that they have, flying through the sky unattached to earthly chains. For some, wings can be a symbol that they have faced difficult times, or have made bad choices, but still are intrinsically good at heart – much as in the motif of the fallen angel. Wings have a duality that enables them to represent both power and strength, as in the wings of an eagle, and beauty and gentleness, as in butterfly wings. Whatever form they take, and even if they have no particular meaning attached to them, their beauty is enough to make them aesthetically pleasing to the eye.

Wolf

The image of a wolf often has a deep ambivalence: suggesting both the aggressive, "animal" side of nature, and the loving protectiveness of the

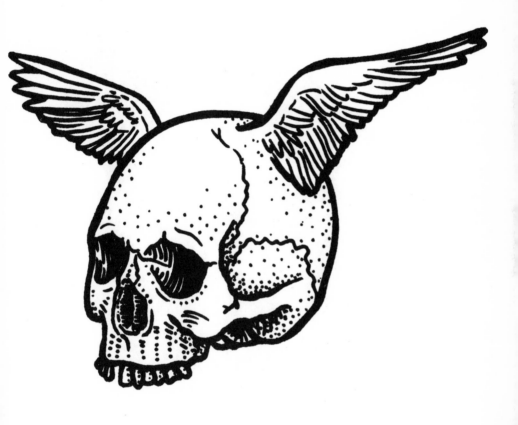

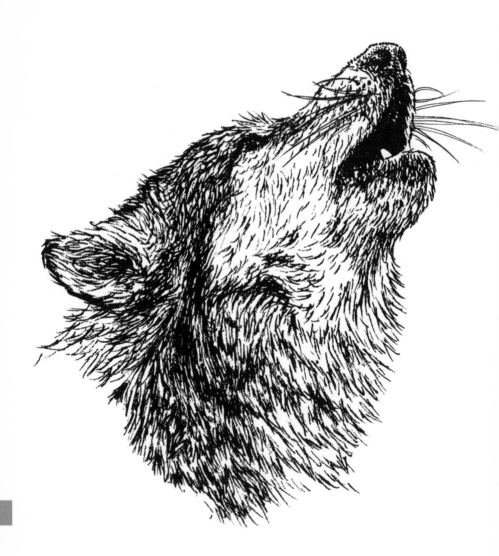

pack. In the novel *Steppenwolf* (1927) by the German-born Swiss writer Hermann Hesse (1877–1962), the protagonist is a homeless loner, wandering the city, unsure whether he is a wolf with a higher spiritual nature or a wild animal like the "wolf of the steppes". A wolf is seen as a proud, powerful beast who is capable of both great love and great violence. On the one hand, it is a guardian, protecting its family and those it loves, and, on the other hand, a devil-like trickster who ruthlessly hunts at night. In fairy tales, the wolf is manipulative, cunning, and resourceful, but warriors use the wolf as a symbol of ingenuity, strength, courage, and power. Our ambivalent attitude to the wolf comes to the fore in the werewolf – by day a normal man, by night a savage beast.

X

The "X" with which many followers of the Straight Edge punk movement get tattooed (most commonly on the back of their hands) originates from one of the core principles of the subculture – abstinence from alcohol, tobacco, and drugs. According to an interview with the US Straight Edge band The Teen Idles, this form of identification started in the 1980s when the band was on tour in the United States. The story goes that, when the band arrived at one of the clubs where they were scheduled to play, the club's management discovered that all the members were under 18 and therefore strictly should have been denied access. As a compromise, they were all marked with a large "X" on the back of their hands, as a way to show the bar staff that they were not to be supplied with alcohol. When the band returned to their hometown of Washington, DC, they urged other clubs to do the same to their patrons so that teenagers under the legal drinking age could see their shows without being served alcohol. The idea quickly took off and soon the Straight Edge movement adopted the "X" as a symbol of the lifestyle.

Yakuza

Under the Shoguns (the military dictators who effectively ruled Japan from 1192 to 1867), many Japanese criminals would be tattooed while in prison, so that, after their release, they would stand out from ordinary citizens. Ostracized as social outcasts, these criminals gathered together to form highly organized and hierarchical gangs, which became known as yakuza. Because tattoos were given to the criminals when they had committed crimes, the very marks that were supposed to show their wayward lives soon became status symbols instead. It was not long before yakuza members began to tattoo themselves, which in itself became a sign of courage and determination, as the tattoos were done in the traditional "hand-poked" fashion, which was a very painful process. In addition, getting tattooed was expensive, so having a full bodysuit was a sign of success in business pursuits. Traditionally, Japanese bodysuits end just above the ankles and wrists and just below the neckline, so that the tattoos cannot be seen when wearing clothes – a way to hide a yakuza's criminal leanings while out in polite society. Often, the girlfriends and wives of yakuza members also get tattoos to show their loyalty to their menfolk and their affiliation with the gangs.

Y

Yantra

SEE ALSO
Chakra *p47*
Ganesha *p95*
Mandala *p133*
Om *p157*
Sanskrit *p192*

The Sanskrit word for "instrument", the Hindu mystical diagram known as a yantra, is believed to have esoteric powers and is used in Eastern spiritual cultures as a form of focus for meditation or to balance the mind. A yantra typically consists of several concentric rings of usually geometric symbols (squares, circles, triangles) arranged around a central point (*bindu*), which signifies unity or the origin of creation. As one follows the concentric patterns, from the outside in, one's mind is drawn towards enlightenment.

Yin and yang

SEE ALSO
Infinity symbol *p108*
Mandala *p133*
Tiger *p218*
Yantra *p244*

There have been many different Chinese philosophies through the ages, but one of the most consistent and enduring ideas has been that of yin and yang. As a symbol, its power lies in the way that it so effortlessly encapsulates a concept that has so many complex layers. Whatever idea is attributed to it, its basic, overriding definition is that of completeness – two separate and opposing attributes that combine to form a single whole. Its very popularity as a symbol is due to its simplicity and openness to interpretation, ranging from the connections between the masculine (yang) and the feminine (yin) to the relationship between evil (yang) and good (yin). In its basic form, it shows that opposite forces are forever in pursuit of balance and that, within each separate part, there is a smaller component of its opposite.

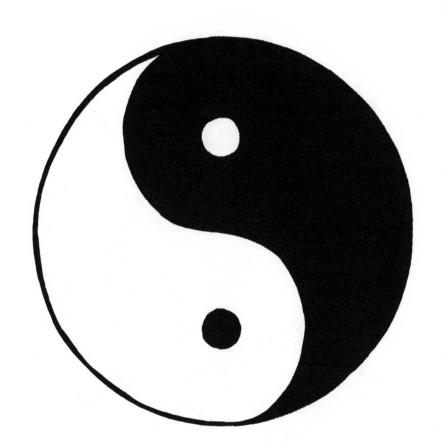

Z

Zodiac

..

The word "zodiac" derives from ancient
Greek and can be translated as "circle of
animals". Though it was originally used as a
way to demarcate the heavens, it is now mainly
associated with astrology and horoscopes. With
each sign corresponding to a person's date of
birth, and each sign having not only a symbol but
an image associated with it too, the astrological
zodiac has long been used as a source of symbols
for the self – a way to identify one's place in the
universe. Alongside Western astrology, other
cultures have their own interpretations of
the zodiac, as found, for instance, in Chinese
and Hindu beliefs. On the whole, these various
zodiacs follow the same naming conventions
and date lines, except for the Chinese zodiac,
which not only has a completely different set of
names, but also follows a different dating system.
Interestingly, within Chinese astrology, not only
do the months have different names, but also the
years, days, and hours.

0-9

13

See "Lucky 13".

420

In autumn 1971, in northern California, a group of five teenage friends who called themselves the "Waldos" met at 4.20 p.m. underneath a statue outside San Rafael High School. The friends were cannabis smokers and they had come into possession of a hand-drawn map that supposedly showed the way to a crop of cannabis that had been abandoned somewhere in the San Francisco region. Though no one knows for sure whether this is really how the name came about, it is the strongest story to circulate about why, within cannabis culture, the term "420" (pronounced like the clock time "four-twenty") is used to denote a person who uses cannabis. The number has long since fed through to mainstream culture and is now almost an unofficial brand, seen on clothing and, of course, in tattooing. Many cannabis users take 20 April (shown as 4/20 when using the American date format) as an unofficial holiday, taking part in marches or conferences to militate for the legalization of cannabis. According to the writer and activist Steven Hager, 4.20 p.m. should be the socially acceptable time to start smoking cannabis.

666

The number 666 is a prime example of how a symbol can change over time while at the same time still retain its original power. In Christian folklore, the number represents Satan and his followers – it is the "Mark of the Beast". The reason for this lies in a few lines in the Book of Revelations (13:15–18) where it is foretold that a beast will rise from the sea, foreshadowing the fall of man, and that he will be marked with the number 666. Originally, early Christians thought that the passage referred to an actual physical beast, but today it is usually considered in a metaphorical light, as, for example, a symbol for the new world order. In popular culture it has largely lost its religious connotations and is most closely associated with the horror genre, as in the 666 mark carried on his neck by Damien in the classic film *The Omen* (1976).

 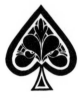 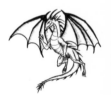

 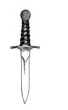

Index

254

Acknowledgments

Trent would like to thank: my children, Kayley, Eden, Sidney, and Hunter, the most beautifully amazing kids a father could ever wish for – I am so proud of you, you keep me inspired daily; Mum and Dad for nurturing my love of reading from an early age and for your constant support; Robyn, Brian, and Mia ... we need to see more of one other – I love you!; Sally and George for giving me a safe place to unravel and then rebuild myself as a better person; Lorna, my spiritual anchor; Stuart Mears and everyone at Jazz Publishing for putting up with me for all these years, especially Sion Smith for giving me my first writing gig; my Rink Family – you lot have the unnerving ability to keep me sane while at the same time driving me totally insane ... though I wouldn't have it any other way; Joe Cottington, Polly Poulter, and everyone at Octopus for putting their faith in me on this project; our amazing illustrator, Ashley Tyson, for gracing my words with her artistry; and, of course, to the tattoo artists who have permanently laid down my life journey on my skin – Lucky, Phil Webster, Rob Bates, Lee Reynolds, Matt Henning, Marc Nutley, Paul Joyce, Klunky, Glenn CuZen, Derek Nelson, Tom Harris, Dano Collins, Koen Chamberlain, Reverent Rudles, Johny Mathews, Phil Kyle, and Matt Vinyl.

An Hachette UK Company
www.hachette.co.uk

First published in Great Britain in 2016 by
Mitchell Beazley, a division of Octopus
Publishing Group Ltd, Carmelite House,
50 Victoria Embankment, London EC4Y 0DZ

www.octopusbooks.co.uk
www.octopusbooksusa.com

Distributed in the US by Hachette Book Group,
1290 Avenue of the Americas, 4th and 5th Floors,
New York, NY 10020

Distributed in Canada by Canadian Manda Group,
664 Annette St., Toronto, Ontario, Canada M6S 2C8

ISBN 9-781-78472-177-0

A CIP catalogue record for this book is available from the
British Library.

Printed and bound in China

10 9 8 7 6 5 4 3 2

Commissioning Editor: Joe Cottington
Creative Director: Jonathan Christie
Illustrator: Ashley Tyson
Editor: Pollyanna Poulter
Copy Editor: Robert Tuesley-Anderson
Production Manager: Caroline Alberti

Trent Aitken-Smith is an international tattoo journalist and editor
of *Tattoo Master* magazine.

Ashley Tyson is a tattoo artist at the award-winning Xotica studio
in London.

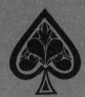